New Hampshire Patterns

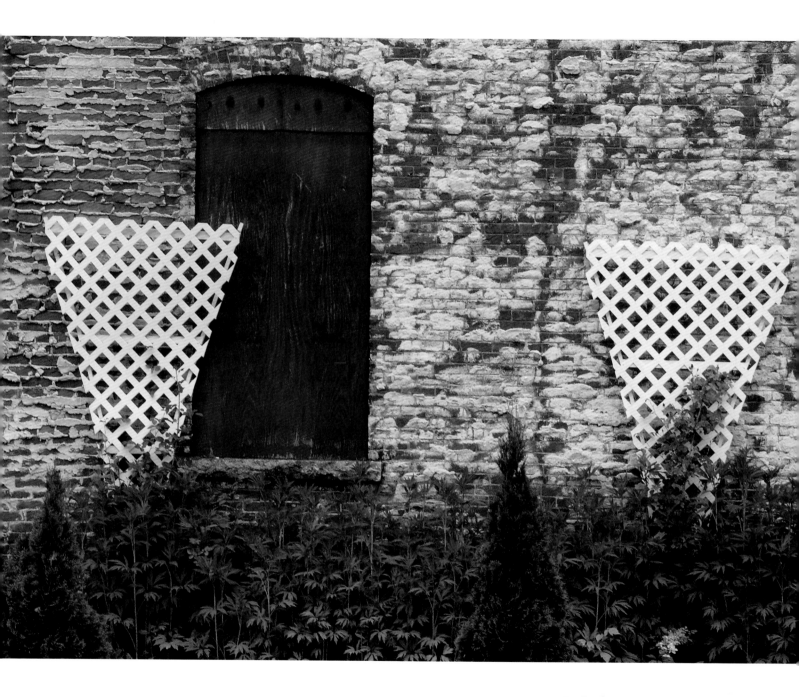

New Hampshire Patterns

Photographs by Jon Gilbert Fox • Text by Ernest Hebert

University Press of New England Hanover and London

*To Ed Shapiro, for the gift of the Alfa Romeo
Spider Veloce that afforded wide and wonder-
ful views of the state and made the roadways
much more enjoyable*

*To the Public Radio stations of New Hamp-
shire, Maine, Vermont, and Massachusetts,
which kept me company when I could get good
reception on the Alfa's lousy radio (and thanks
to all the Country music default stations that
always came in loud and clear)—J.G.F.*

*And to the People of New Hampshire, and especially those in Keene and
the Monadnock Region—E.H.*

Frontispiece: Franklin.

Published by University Press of New England,
One Court Street, Lebanon, NH 03766
© 2007 by University Press of New England
Printed in China
5 4 3 2 1

Library of Congress Cataloging-in-Publication Data

Fox, Jon Gilbert.
 New Hampshire patterns / photographs by Jon Gilbert Fox ; text by
Ernest Hebert.
 p. cm.
 ISBN-13: 978–1–58465–525–1 (cloth : alk. paper)
 ISBN-10: 1–58465–525–9 (cloth : alk. paper)
 1. New Hampshire—Pictorial works. 2. New Hampshire—Social life and
customs—Pictorial works. 3. New Hampshire—History, Local—Pictorial
works. I. Hebert, Ernest. II. Title.
 F35.F69 2007
 974.2'0440222—dc22 2007003304

Contents

A Word from Jon Gilbert Fox

New Hampshire Patterns began as a photographic odyssey to discover and document the "patterns" of geography, population, philosophy, celebration, and daily life that define the Granite State. Throughout the calendar year I traveled to New Hampshire's small towns and cities for annual events and parades, joined thousands at the annual motorcycle week get-together, ate and danced with Franco-Americans, visited the birthplaces and homes of distinguished citizens, and photographed the landscape. I have tried to present the light, shadows, and textures of New Hampshire to illuminate its "Live Free Or Die" motto, which I believe accounts for the state's remarkable diversity of people, place, and spirit.

Although the "Old Man of the Mountain," the rock profile that symbolized New Hampshire for so long, has slipped into history, *New Hampshire Patterns* offers a combination of photographs and essays intended to keep that memory, and many other aspects of the richness of the Granite State, alive.

The backside of one of Mary Baker Eddy's (founder of The Church of Christ Scientist) numerous New Hampshire houses, a former mill near Dorchester.

A Word from Ernest Hebert

In the late nineteenth century, my grandparents on both sides of my family moved from French Canada to New Hampshire to work in mills in Manchester and Keene. I've lived sixty-two of my sixty-five years in this state. I married a New Hampshire girl (Medora Lavoie from Dover); we raised our children here. New Hampshire is my home and the source of inspiration for my novels. These essays—inspired by Jon Fox's photographs—are the first I have ever written about my relationship with this place that I love so much but that sometimes alienates me; they constitute an exploration into my past and into the heart of New Hampshire.

HISTORICAL
PLACES

Memorial Service for The Old Man

As a kid growing up in southwestern New Hampshire I never gave much thought to The Old Man in the Mountain, the state's official symbol. He was all too familiar a presence, appearing on license plates, post cards, and PR flyers. You couldn't pick up a newspaper or buy a quart of maple syrup without seeing that profile of a man who was really a rock ledge shaped by a glacier and other natural forces a few thousand years ago. In fact, I didn't even know the exact location of Profile Mountain. North, someplace.

Years later as a newspaper reporter I had occasion to drive through Franconia Notch headed for Berlin on assignment. I drove right by The Old Man in the Mountain and never noticed. At least by then I knew what a notch was, a New Hampshire word for mountain pass.

More years went by. One fall day I had some time to myself, and I decided to explore the North Country. I told my wife I was going to see the foliage. She knew this was a joke. It was late November, long after the leaves of the hardwoods had fallen. I love that bleak time before the first snow when the trees are like dark monuments and the ground, crispy with fresh fallen leaves, seems alive.

I avoided the interstate and drove north on Route 10 to Littleton, picked up Route 135 along the Connecticut River to Route 3 and motored all the way to the Canadian border past the Connecticut Lakes. In olden days sawyers cut pine and spruce in this area and floated at least some of the logs down the river all the way to Long Island Sound, 345 miles, at one time the longest log drive in the world.

I saw a cow moose and her calf knee deep in marsh water;

The site of the former " Profile," " Great Stone Face," "Old Man of the Mountain," the seemingly indestructible symbol of the State of New Hampshire, after the " face" slid down the mountain into rubble, near Franconia.

I saw a flight of geese hurrying south squawking to beat hell. I took notes, not about the flora and the fauna but about the book I was writing at the time. I find that the kind of scheming thinking I naturally fall into while driving a car is just what I need to plot a book.

I turned around and shot down the interstate headed back home, expecting to reach Plymouth around dusk. In Franconia Notch I noticed clouds moving in and thought it might snow by morning. And then I saw him: The Old Man in the Mountain. The sight took me completely by surprise. I could not connect the real thing with the photographs and corny graphics I'd seen all my life, those tired cliches.

This was an entirely different experience. It was as if I was the first man to discover this wonder of nature. When I arrived home, I gushed: "Guess what, I saw The Old Man in the Mountain." My wife was amused. "It's about time," she said.

A couple years later I was in the North Country again chasing down a story about a legendary Indian named Metallak. I read that, when Metallak was eighty, he was living in the deep woods as a trapper when his wife died. It was winter and he didn't have the tools or the strength to dig through the frozen ground to bury her. To preserve her remains for burial in the spring he smoked her over a smoldering fire. I've always admired people who can solve problems in novel ways.

Metallak was part of a small family band in northern New Hampshire and the Magaalloway Region of Maine. His children left for Canada, but Metallak refused to follow. He died, the story goes, at age 120 in 1847, the last known Abenaki in the Great North Woods. A memorial, established by the state government, stands near his grave in Stewartstown.

In my imagination I associated Metallak with The Old Man in the Mountain. They were embodiments of a feeling that comes over you in the North Country, a weird fusion of grandeur and gloom, a sadness at the passing of an era, the sheer difficulty of human existence, but at the same time confirmation of the resilience of human spirit. The Old Man of the

Mountain was gatekeeper, and Metallak was the human face of the Great North Woods.

Flash ahead in time to May 3, 2003. I'm out of state driving and listening to NHPR, my favorite radio station. I'm at the end of the FM signal, but I can pick out the words well enough: "The Old Man fell from his mountain today."

Next day it's Sunday and it's my birthday. I'm sixty-two. I tell my wife I have to travel to Franconia Notch to see for myself. "I'm going with you," she says.

On the trip from West Lebanon to the notch we hardly say a word to one another, living in our private thoughts. It's as if we're going to church. I'm thinking that it's ridiculous I should feel this way, grieving for a rock. Old self-doubts from my teen years come back to haunt me. I feel alienated from job, country, everything. I want to retire from writing. Quit teaching. Move out of state, maybe Seattle where our oldest daughter lives. Mainly, I feel stupid for letting my emotions carry me.

Everything changes when we reach the parking lot of the Cannon Mountain Tramway. It's off season for skiing, yet the lot is almost full. No need for the sign: "Old Man Viewing Area." We just follow the people coming and going on the path. It's comforting knowing that we're not the only ones mourning a rock.

We arrive at the viewing area. In front of us is Profile Lake; rising steeply above it is Profile Mountain, and then . . . Nothing! No Old Man. Just a featureless cliff face.

A woman nearby weeps silently. People stare up at the Nothing, as if concentrating real hard could bring back an old departed friend.

We leave, walking slowly in a funeral march with scores of others, and the sadness lifts. I feel oddly elated being with people who feel as I do. As we approach the parking lot, I'm trying to remember where I put my car and my eyes rove among the vehicles. Suddenly, I'm aware of a sight nobody has seen before and probably never will again. You'd expect to see license plates from many different states in this tourist spot. Today they're all from New Hampshire.

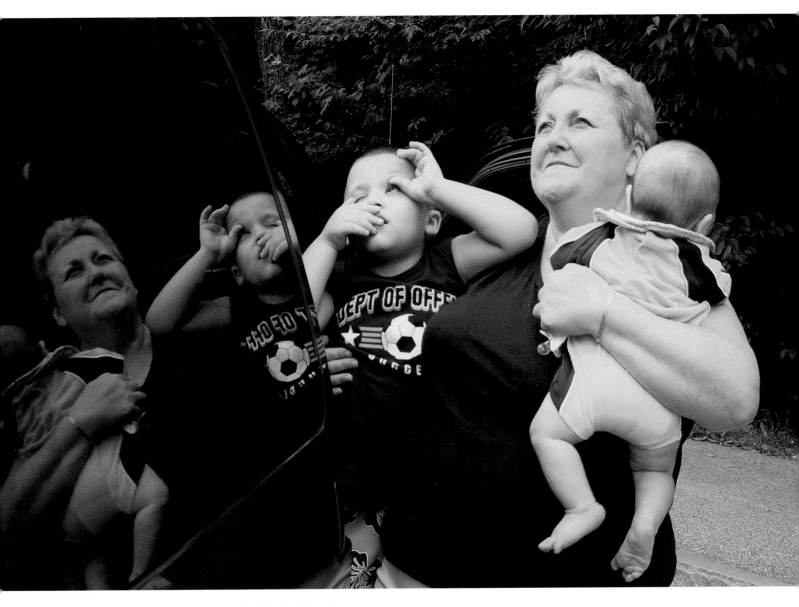

A grandmother attempts to point out and explain the Great Stone
Face That Is No More to another generation, near Franconia.

One of the lighthouses at the entrance to Portsmouth harbor.

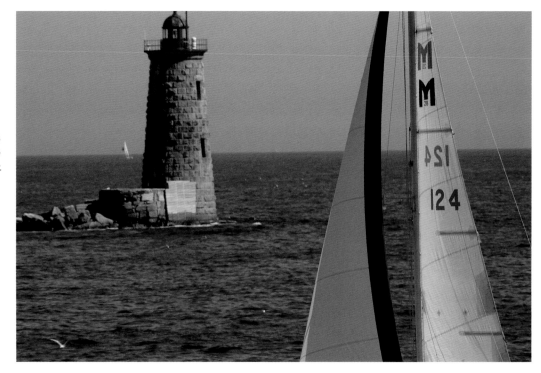

The lighthouses at the entrance to Portsmouth Harbor.

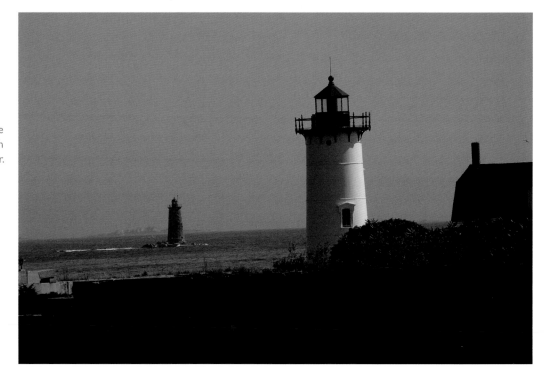

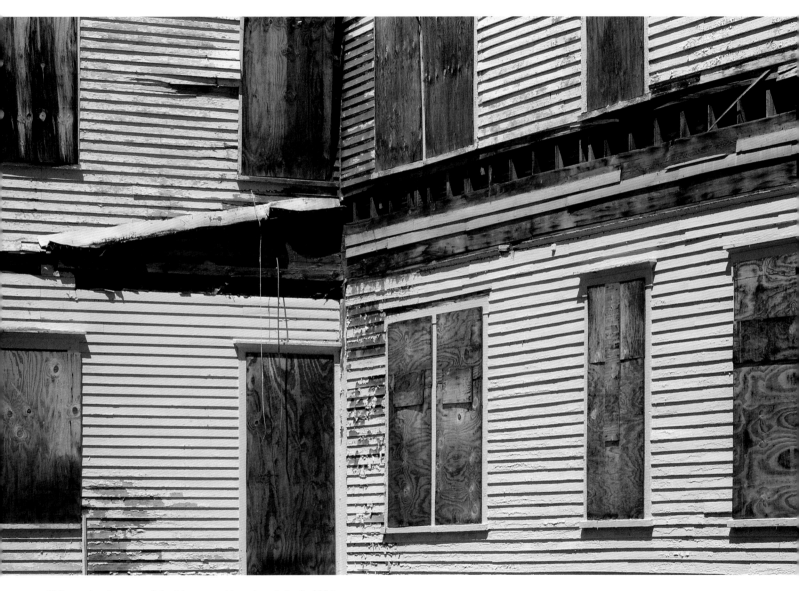

This used to be one of the biggest and best hotels in the White Mountains, in Bethlehem.

The view from the back door of Daniel Webster's birthplace, near Franklin.

8

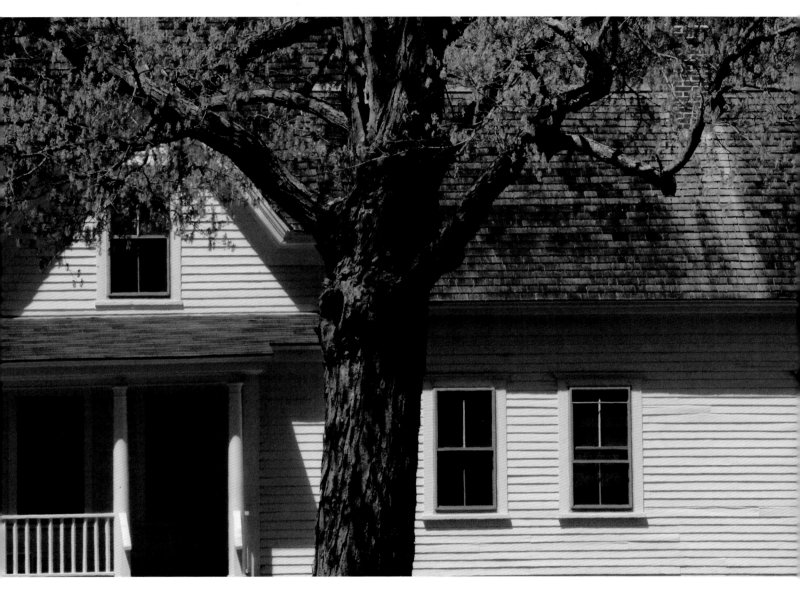

The poet Robert Frost's farmhouse in Derry.

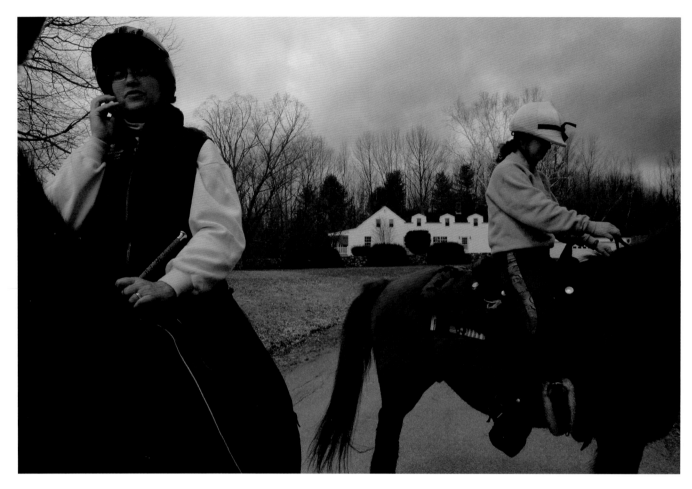

Local riders pause in the driveway of the home that housed Grace Metalious when she shocked the neighbors and wrote Peyton Place about them, in Gilmanton.

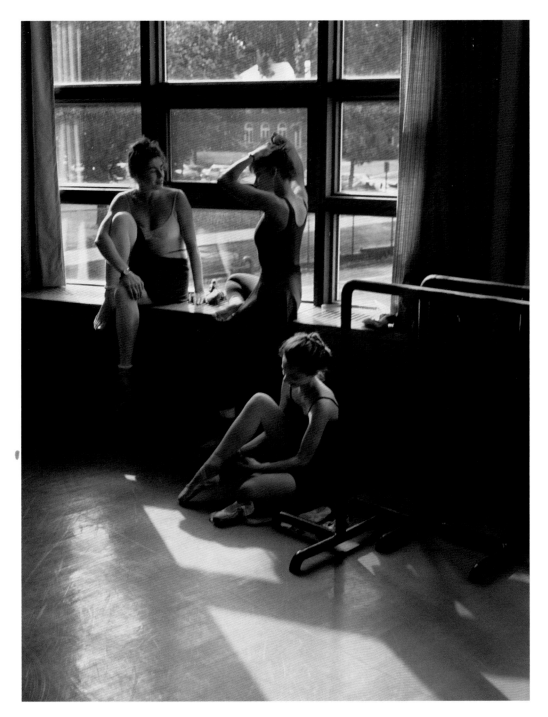

Dancers take a rest during
rehearsal at Dartmouth
College, in Hanover.

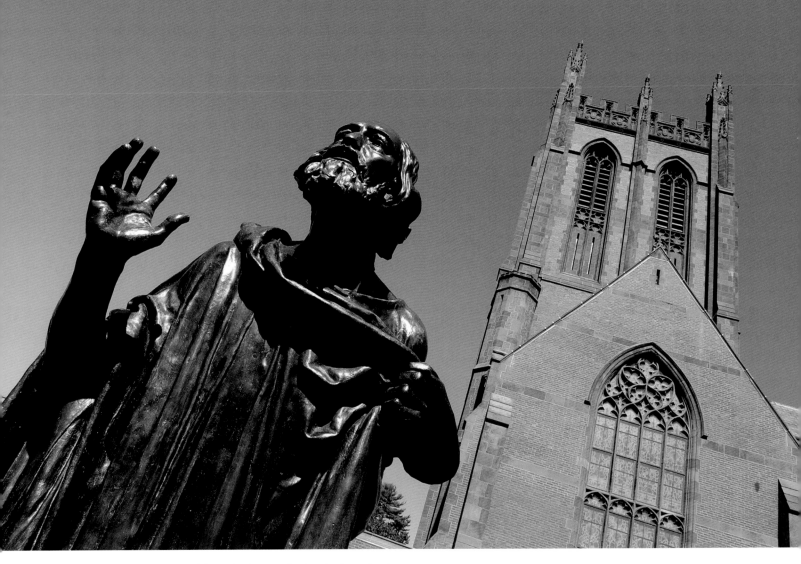

One of the Burghers of Calais, by Auguste Rodin, pleads to the sky
in front of the chapel at St. Paul's School, in Concord.

A statue of Revolutionary War General Kosciusko seems to stride across the rooftops, in Manchester.

A cloud forms a flag over the dome of the New Hampshire State House, in Concord.

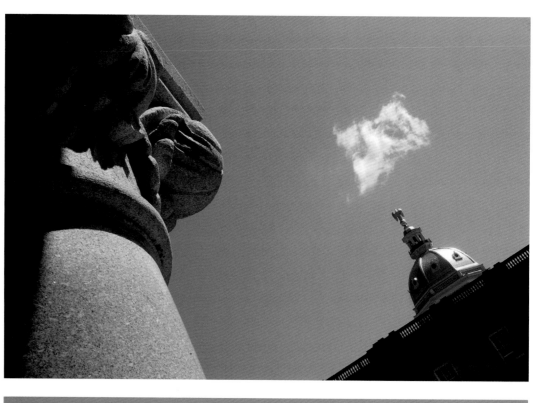

The New Hampshire State flag seems to reach out and touch the dome of the capitol building.

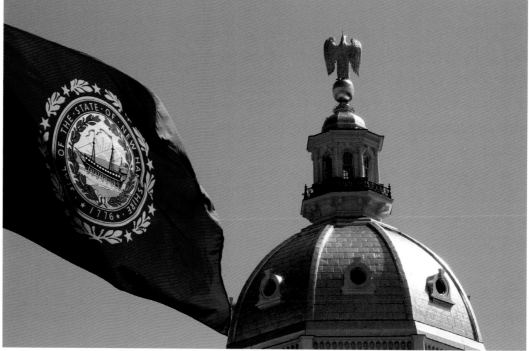

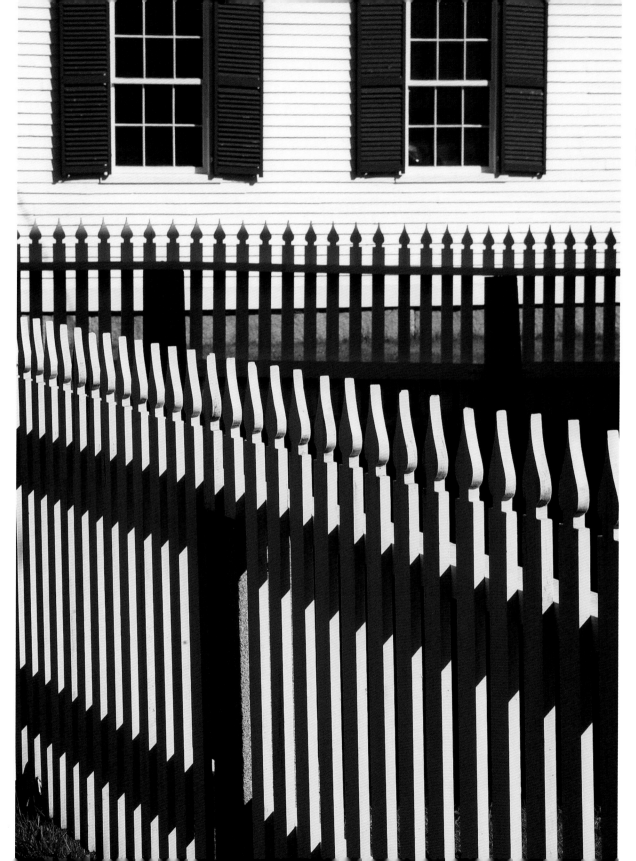

Fences and windows at the Shaker Village, in Canterbury.

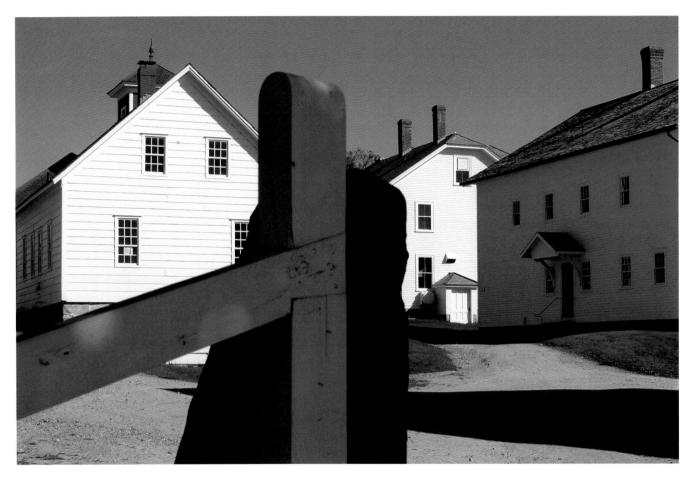

Buildings at the Shaker Village, in Canterbury.

Wood stacked and seeds drying for the winter at
the Shaker Village, in Canterbury.

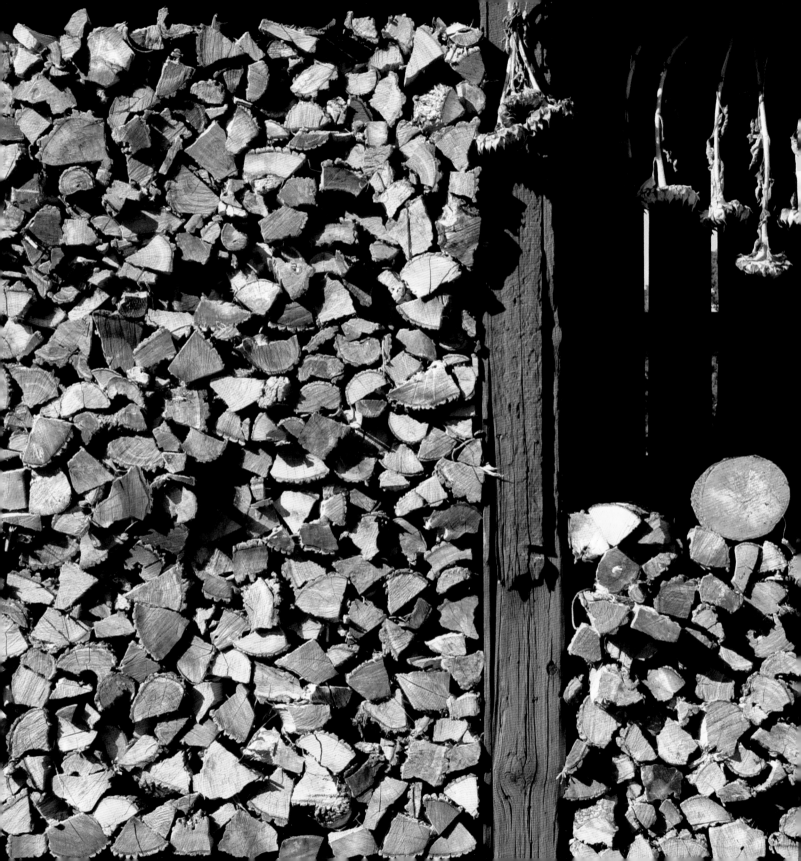

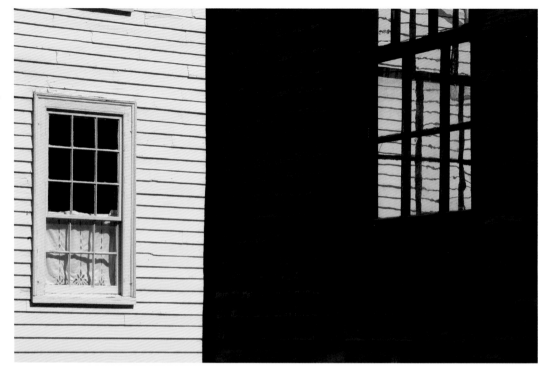

Windows at Strawbery Banke, in Portsmouth.

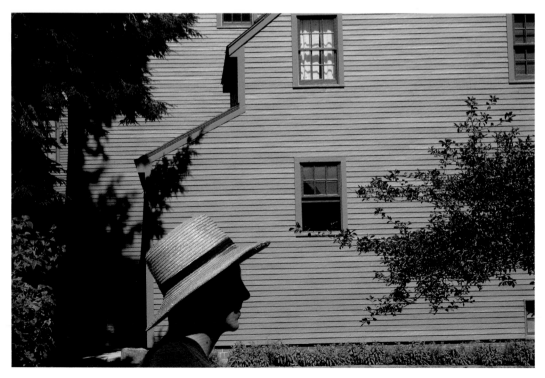

A hat and houses at Strawbery Banke, in Portsmouth.

18

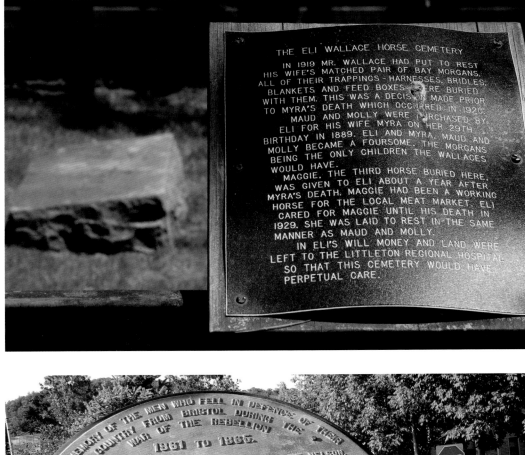

THE ELI WALLACE HORSE CEMETERY

IN 1919 MR. WALLACE HAD PUT TO REST HIS WIFE'S MATCHED PAIR OF BAY MORGANS. ALL OF THEIR TRAPPINGS - HARNESSES, BRIDLES, BLANKETS AND FEED BOXES - WERE BURIED WITH THEM. THIS WAS A DECISION MADE PRIOR TO MYRA'S DEATH WHICH OCCURRED IN 1920.

MAUD AND MOLLY WERE PURCHASED BY ELI FOR HIS WIFE MYRA ON HER 29TH BIRTHDAY IN 1889. ELI AND MYRA, MAUD AND MOLLY BECAME A FOURSOME. THE MORGANS BEING THE ONLY CHILDREN THE WALLACES WOULD HAVE.

MAGGIE, THE THIRD HORSE BURIED HERE, WAS GIVEN TO ELI ABOUT A YEAR AFTER MYRA'S DEATH. MAGGIE HAD BEEN A WORKING HORSE FOR THE LOCAL MEAT MARKET. ELI CARED FOR MAGGIE UNTIL HIS DEATH IN 1929. SHE WAS LAID TO REST IN THE SAME MANNER AS MAUD AND MOLLY.

IN ELI'S WILL MONEY AND LAND WERE LEFT TO THE LITTLETON REGIONAL HOSPITAL SO THAT THIS CEMETERY WOULD HAVE PERPETUAL CARE.

The Eli Wallace Horse Cemetery, an historic site in Littleton.

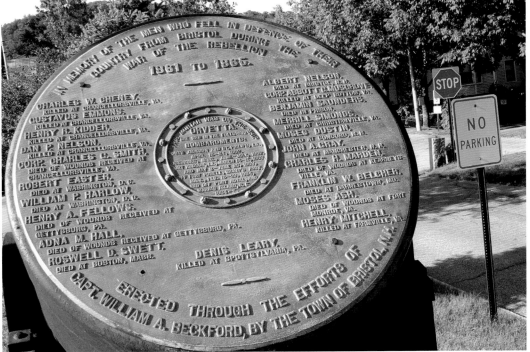

A different type of Civil War memorial, made from a mortar, in Bristol.

19

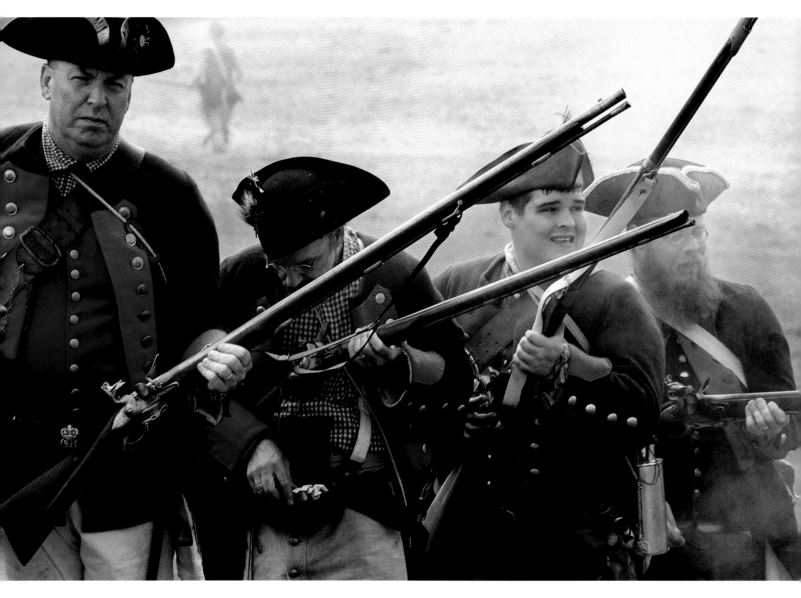

Reenacting the French and Indian War at Old Fort Number Four, in Charlestown.

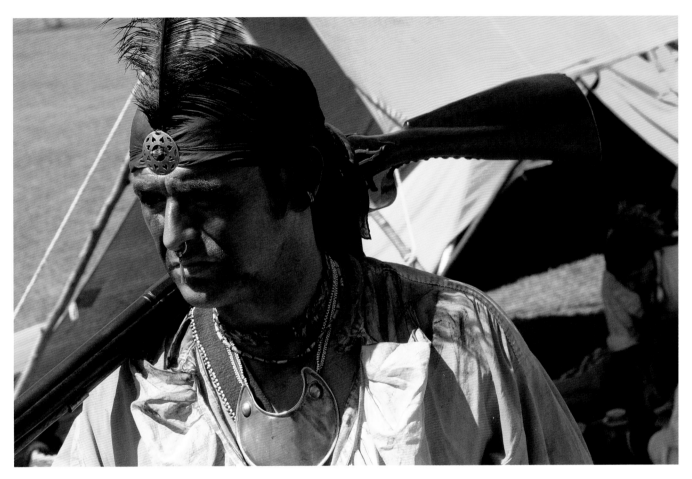

Playing a native in the French and Indian War, in Charlestown.

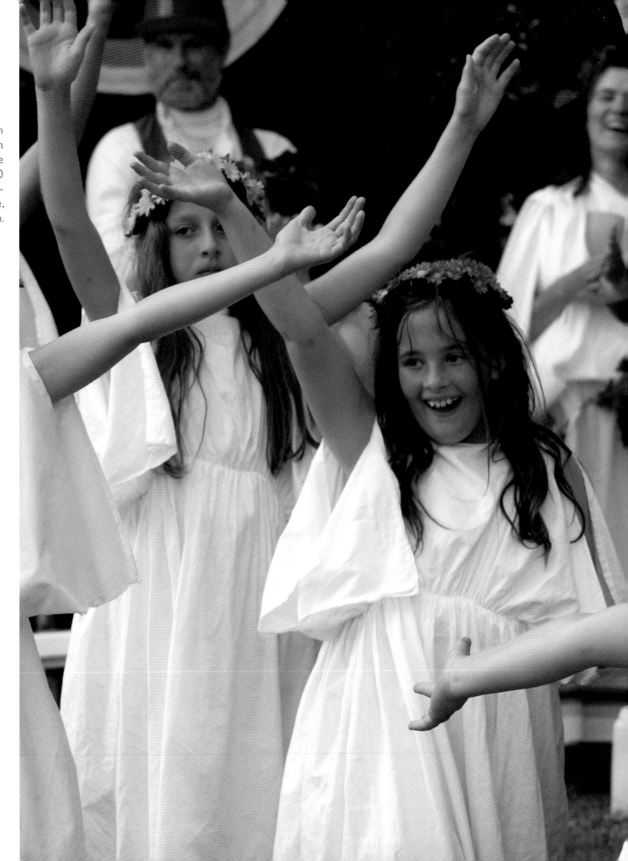

Recreating "The Golden Bowl," a masque put on by the inhabitants of the Cornish art colony 100 years ago, at the Saint-Gaudens National Site, in Cornish.

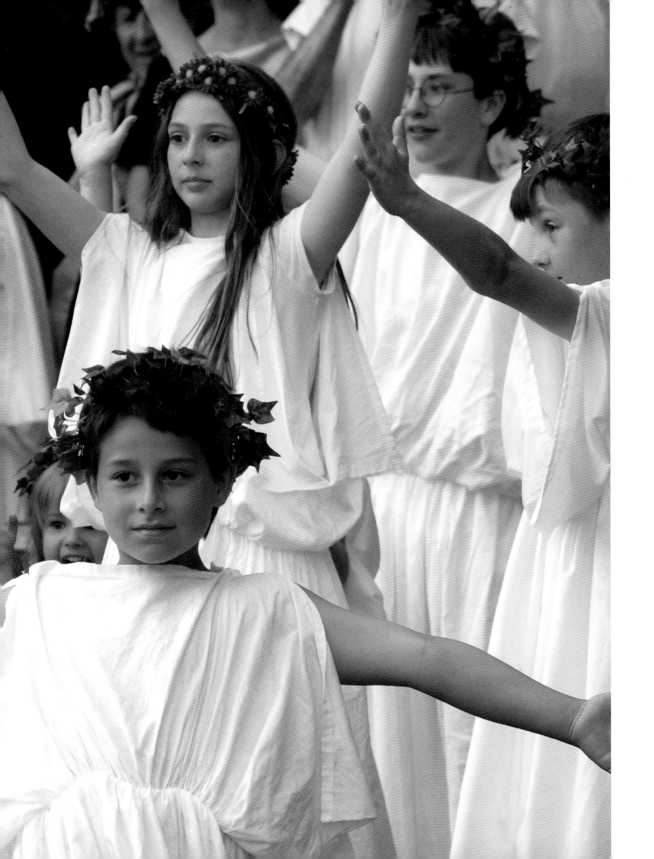

The "Arch of Tilton" sits atop the highest point in the town of Tilton.

One of the Isles of
Shoals, in the ocean off
Portsmouth.

25

The Cornish-Windsor Bridge, claimed to be the longest covered bridge in the United States, spans the Connecticut River between the New Hampshire and Vermont towns.

26

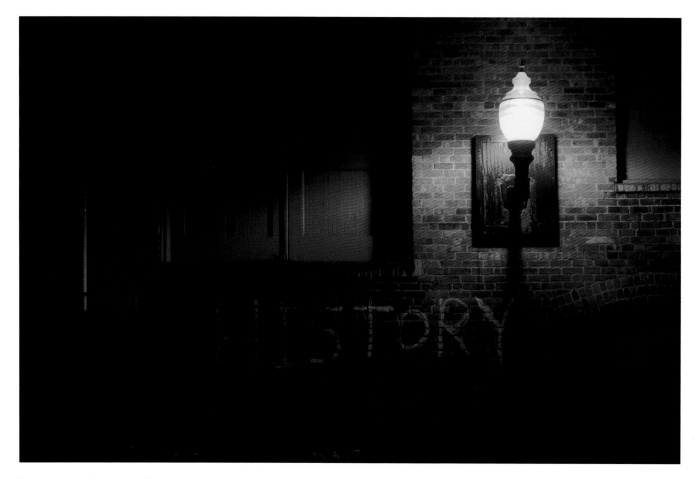

Appropriate graffiti on a wall in Keene.

Taking a quick break between pit stops, at the Loudon racetrack.

EVENTS

Parading in Andover.

Encounters with Presidential Candidates

Work for a small, New Hampshire daily newspaper, as I did for almost ten years, and you can't help but encounter presidential candidates as they campaign around the state in the New Hampshire primary.

They go into people's houses and talk one-on-one with voters. You see them in grange halls, fire stations, and school cafeterias; you see them outside factories when the 5 P.M. whistle blows and on sidewalks with supporters carrying signs. They even submit to interviews by rookie reporters.

Some of the candidates I saw and talked to in my capacity as a reporter and later free-lance writer included John Anderson, Lamar Alexander, Jerry Brown, George Herbert Bush, Jimmy Carter, Fred Harris, Hubert Humphrey, Ted Kennedy, George McGovern, Eugene McCarthy, Ronald Reagan, and Nelson Rockefeller.

I never took my assignments to interview these giants of our political system too seriously. They were too good at dodging my questions and making the points they wanted to make for me to think I could actually reveal something new, different, and important. I hardly remember what I wrote about the positions they took, but I remember little quirks about their personalities and my sometimes odd reactions to them and their entourages, items that I never wrote about until now.

For example, the candidates often dressed or tried to dress like just plain folk, (the sight of Lamar Alexander, a fine southern gentleman, in a black and red woodsman shirt makes me smile every time I think of it), but their advisors dressed in suit and tie and shined shoes. The contrast between the well-dressed aides and the casually dressed candidate seemed both funny and sad to me, a commentary on the necessity of hypocrisy in public life in America.

The most "presidential" of the candidates in my memory was Nelson Rockefeller, the governor of New York. I saw him in front of the Crystal Restaurant in Keene in 1968, before I became a reporter when I was a college student.

Rockefeller was not particularly tall, but he was deep and broad in the chest and he had a huge head and a commanding profile. You could spot him in a crowd in a split second. His bearing was presidential too. He could have been the reincarnation of a New Hampshire icon, Daniel Webster. Like Webster, he didn't have much luck on the national political scene. Rockefeller ran for president in the Republican primary in 1960, 1964, and 1968. He got beat every time.

Massachusetts Senator Ted Kennedy sticks in my mind as the rudest and most unpresidential of candidates—that is, on one occasion in 1970. He strolled into the office of the publisher of the Keene *Sentinel* with an aide. He was going to give us an interview before a speech at Keene State College later in the day. Waiting to hear what he had to say were myself, two other reporters, the editorial writer, and the publisher himself, James D. Ewing.

Kennedy hardly acknowledged the introductions and did not bother to shake hands with anyone. He sat in a chair with his hands on his knees and his head bowed slightly. He avoided all eye contact. His face was puffy and red. He'd entered with a scowl and it never quite went away. To me he embodied the undisguised contempt that many Massachusetts people have for New Hampshire.

Kennedy mumbled sometimes incoherent answers to our questions, or he simply did not reply. He made no pretense to be interested in anything other than getting out of there.

I have to admit that at the time I had a chip on my shoulder against the Kennedys. Ted's brother John F. was president of the United States and exercised his powers as commander in chief to call out the Army reserves and National Guard in 1960 during a crisis in Berlin. That's not Berlin, New Hampshire (pronounced *Bur*ln) but the German city of Burr-*lin*. I was among those who were called. I was in the army on active duty for a year.

I started forgiving both the Kennedys (and maybe growing up a little) later that day in 1976 when Ted Kennedy spoke to a pretty big crowd on the Keene State campus. He was animated, he was energetic, he was not the same person I'd seen earlier. It was also clear he could never win the presidency. He could not, or perhaps would not, conceal his emotions. He had the appeal of a nineteenth-century orator, not the right delivery for TV. I admired his honesty. Which raises an interesting question: what is more important in a political leader, honesty or tact?

The most impressive candidate one-on-one I met was Jerry Brown, former governor of California. He'd look you in the eye and actually grapple with the question you asked him. A few politicians—very few—articulate a vision, but usually through surrogates or position papers. Jerry Brown did it all by himself through his gift of self-expression.

Another bright, articulate politician was Eugene McCarthy, who ran for President as an anti-war candidate during the Vietnam conflict. I never covered candidate McCarthy, but I met him years later when he was a fellow at Dartmouth College. He talked to a dozen of my students. He read his own poetry, and he analyzed the rhetorical styles of two of his adversaries, George McGovern, his opponent in the Democratic primary, and Richard Nixon. McCarthy demonstrated how their styles of speech were derived from their religious upbringing: McGovern, the Methodist, Nixon, the Quaker. It was a brilliant critique, partly tongue in cheek and partly in earnest.

My favorite interview on the campaign trail was Rosalynn Carter. She had a grasp of policy and a soft, charming manner that entirely disarmed me.

I rarely disliked any of the candidates I covered or even members of their entourages. However, I did form a special animus toward the national press corps that covered the candidates. I never read a piece about New Hampshire by a national press reporter that had any depth or insight. Occasionally, Washington reporters would seek information from me as a local beat reporter. In almost all cases they'd already made up their mind what the news was, and I was merely support for a preconceived idea. They rarely wrote about what the candidates said or where the candidates stood on particular issues. They wrote about maneuverings between various political camps.

It took me a while, but eventually I was able to pick primary winners better than the pollsters. I based my predictions on the nature of the crowds that attended public events held by the candidates. I compared the type of crowd with crowds I'd seen in previous years and how candidates who attracted those crowds did in the New Hampshire primary and in later campaigns.

Take Democrat Fred Harris, for example. He was a governor of Oklahoma, had new ideas, a charismatic personality—definitely presidential material. He drew good-sized crowds, too, but they were mainly 1970s counter-culture types. From previous experience, I knew he was a dead duck. And he was—his campaign got a lot of PR from us press guys, because he was good copy, but he was too much a "hippie" candidate in a time after the counter-culture had had its day. Jerry Brown attracted the same type of people, and his candidacy suffered the same fate as Harris's.

Ten-term congressman John Anderson drove around the state in a van in 1980 campaigning for president as a Republican. He was bright, articulate, warm and engaging. His personality and message of dissatisfaction with both parties drew some of the biggest crowds I covered, but many of the people in his audiences were Democrats. He was a dead duck, trounced by his opponent in the Republican primary, Ronald Reagan. (More about him later.)

Campaigns in small communities, like the ones served by the *Keene Sentinel*, attracted a certain number of local political activists. Over the years no matter who the candidate was you'd see the same people at campaign rallies. When you saw people you'd never laid eyes on before it was time to pay attention.

I noticed this effect with Jimmy Carter. He had a fair local base of Democrats in his audiences that I recognized, but there were many people I'd never seen before, people who reacted to his message: "I'll never lie to you." They were the ones who elected him President in 1976.

In 1980, I saw the same effect again, only this time on the other side of the political spectrum—and bigger. I went to a Ronald Reagan speech held in the gym at Keene High School. He drew the biggest and most enthusiastic crowd I'd seen in a primary campaign. Nearly all the people on hand were fresh faces. The Reagan Revolution was right there in front me, and I wrote it up for the paper.

Many people outside the newspaper trade tell me that newspapers favor certain candidates over others. My experience is that news editors favor candidates whose names fit nicely into headlines, that is, short names. Headline writers do not like candidates whose names have m's or w's because those are the widest letters in the alphabet; headline writers like candidates whose names have narrow letters, i's, l's, and t's. The editors have had their way in American politics in the last few decades.

The candidates with long names were beaten—Hubert Humphrey, George McGovern, Walter Mondale, Michael Dukakis. If you're looking for a conspiracy theory, you can say that the news editors have arranged to have candidates with short names on both sides: Bush, Kerry, Gore, Clinton, Dole, Bush again, Reagan, Carter, Ford, Nixon. Lyndon Johnson is a longish name, but he acquired his office through assassination and when he ran on his own, look at his opponent, Barry Goldwater, a guy with a longer name with a w in it. When the press has to deal with presidents with long names, they shorten them; hence, JFK and LBJ.

I enjoy politics—but from a safe distance. Harry Truman said if you don't like the heat get out of kitchen. I think he used the wrong room in the house for his metaphor. I think he should have said, if you don't like the stink get out of the bathroom.

Back when I was a kid in the 1950s, President Dwight D. Eisenhower came to the Keene bicentennial parade. I joined thousands of others lining Main Street to lay eyes on a president for the first time. The motorcade came by and Ike waved to the crowd, showing the magic smile he was known for. People cheered and waved back. Their unbounded joy scared me. I left the parade glad to be free from the mass euphoria, but confused and upset with myself for my failure to go along with the crowd.

I didn't understand it at the time, but what I intuitively understood was that the presence of celebrity (the American word for royalty) makes people stupid. There is no bigger celebrity than the President of the United States.

I was thinking about the day I saw Ike when I read in the newspaper that President Bill Clinton was going to be in Hanover, only four miles from my home in West Lebanon. I penciled in the date in my calendar to make sure I stayed far away.

Families come together for the Memorial Day ceremonies in Lyndeborough.

Not everyone appreciates the rifle salutes in Lyndeborough on
Memorial Day.

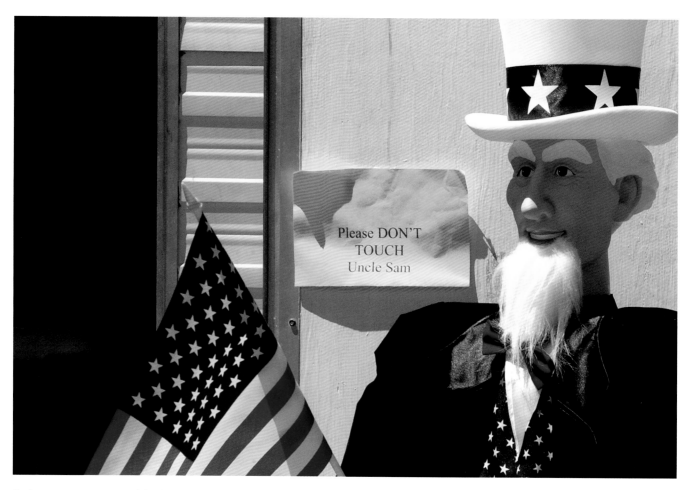

An important message on July 4 in Andover.

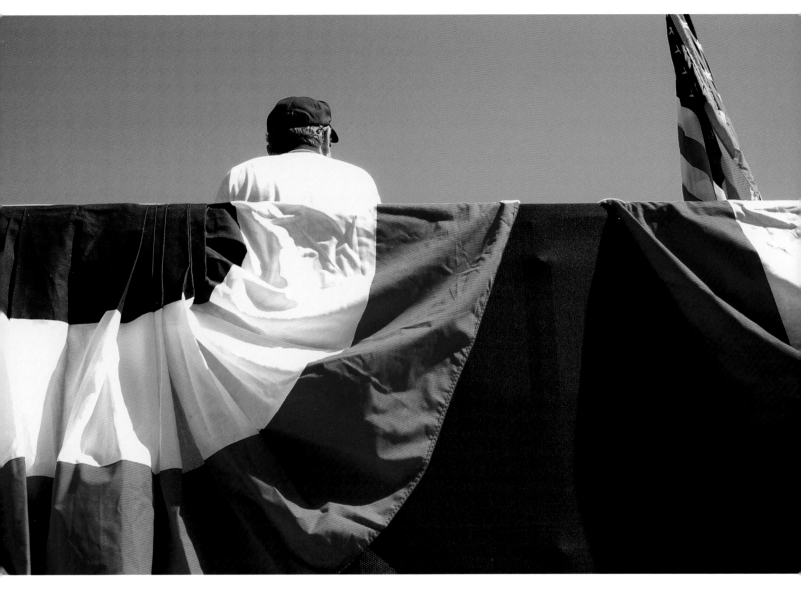

The back of the viewing stand at the Andover Fourth of July parade.

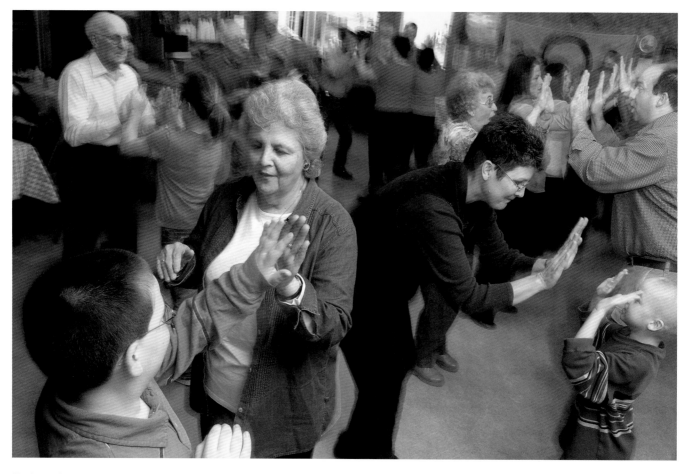

Traditional dances are always a part of the annual Franco-American
dinner in Lee.

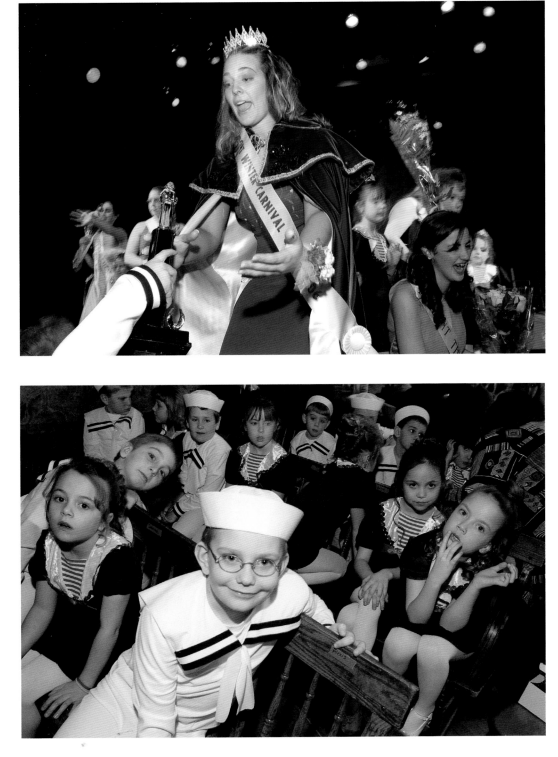

The Queen of the Winter
Carnival, in Newport.

The entertainment for
Queen's Night of the
Newport Winter Carnival.

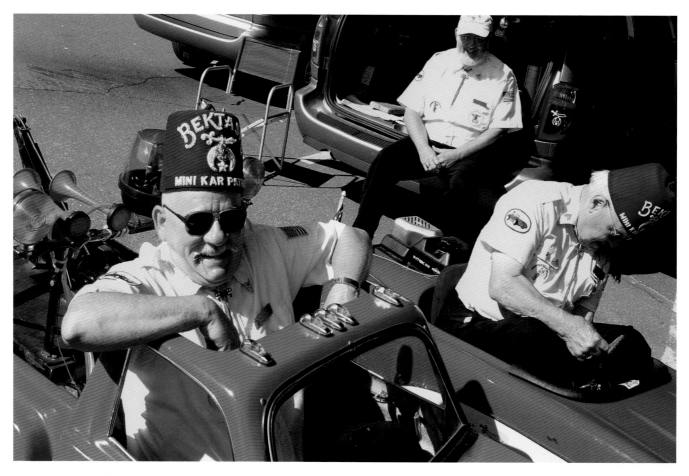

Every summer, the Shriners take over the town and host the big
high school rivalry football game between teams from Vermont and
New Hampshire, in Hanover.

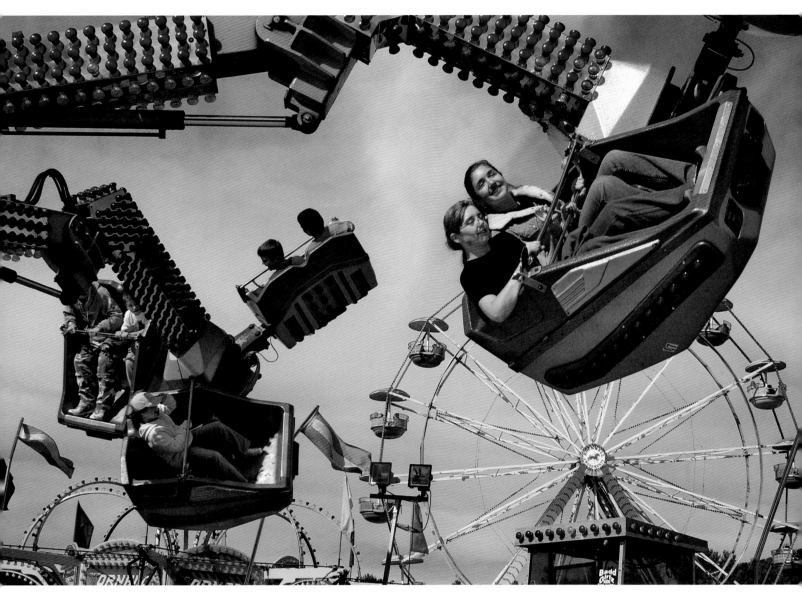

An overhead scene at the annual Deerfield Fair.

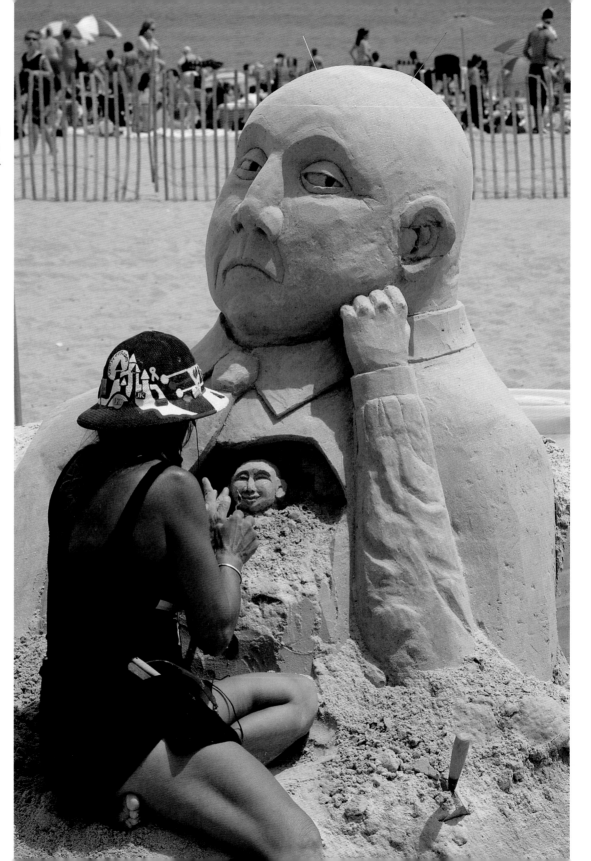

Carving at the annual Sand Sculpture competition, on Hampton Beach.

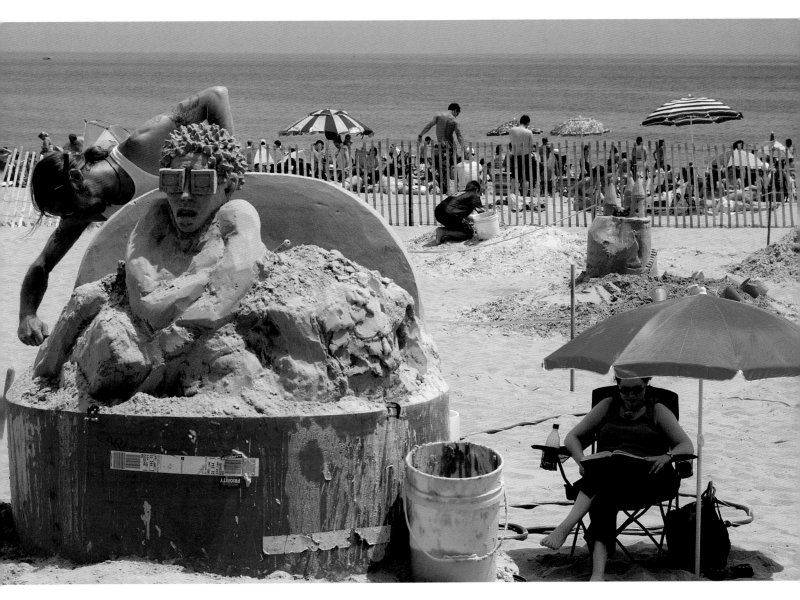

Beach activities during the Sand Sculpture contest in Hampton.

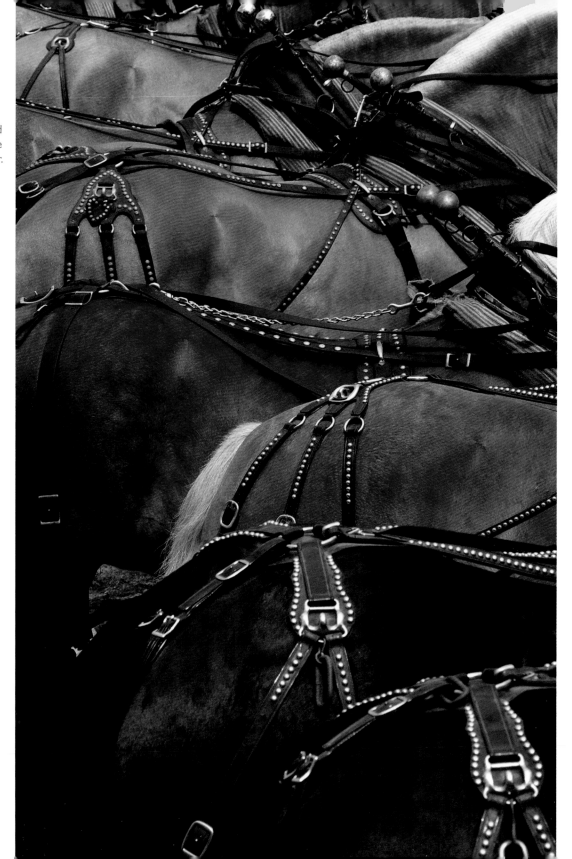

Horses harnessed and waiting to compete at the Cornish Fair.

44

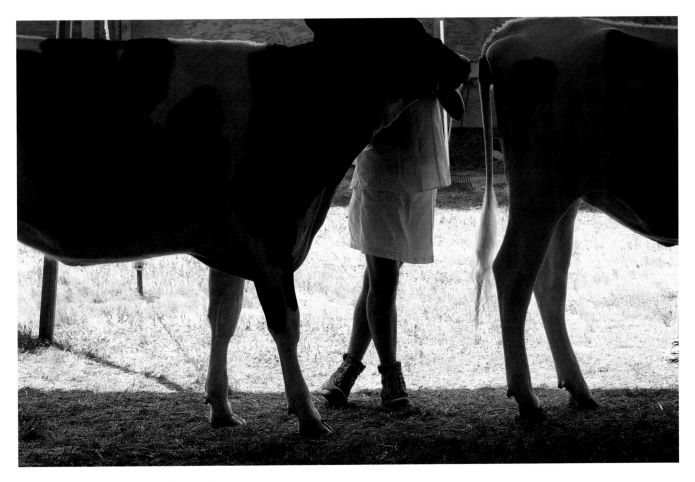

4Her showing her cows at the Cornish Fair.

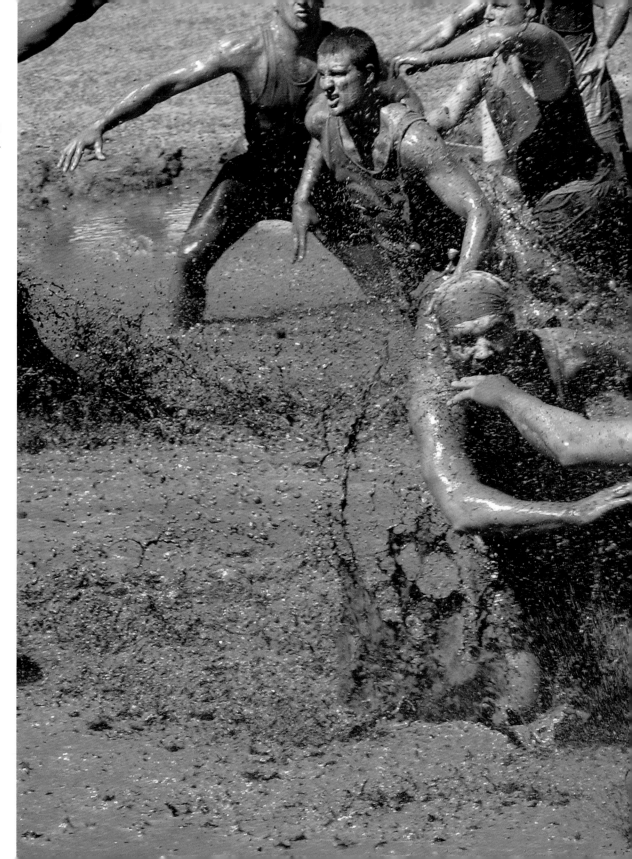

The annual Mud Football Game, in North Conway.

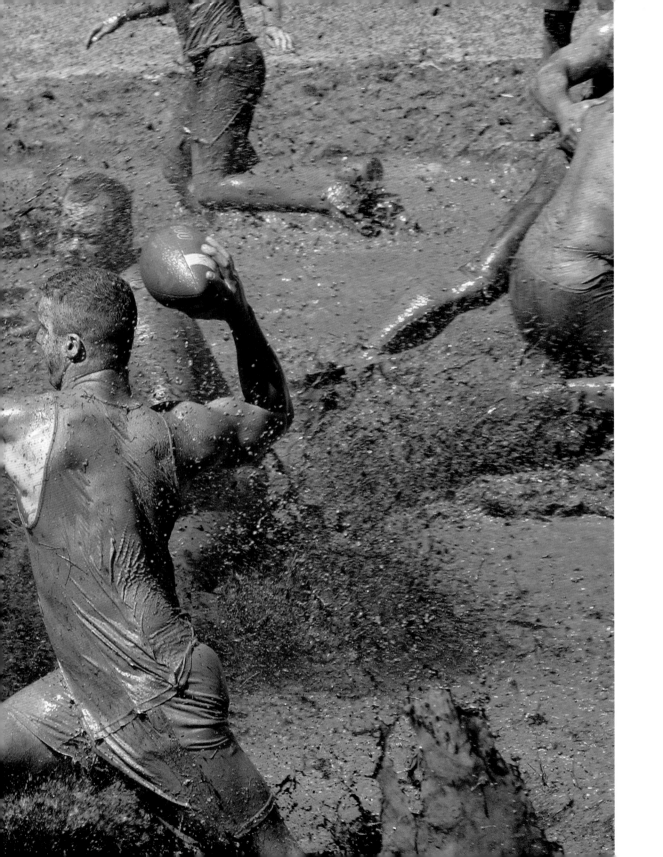

47

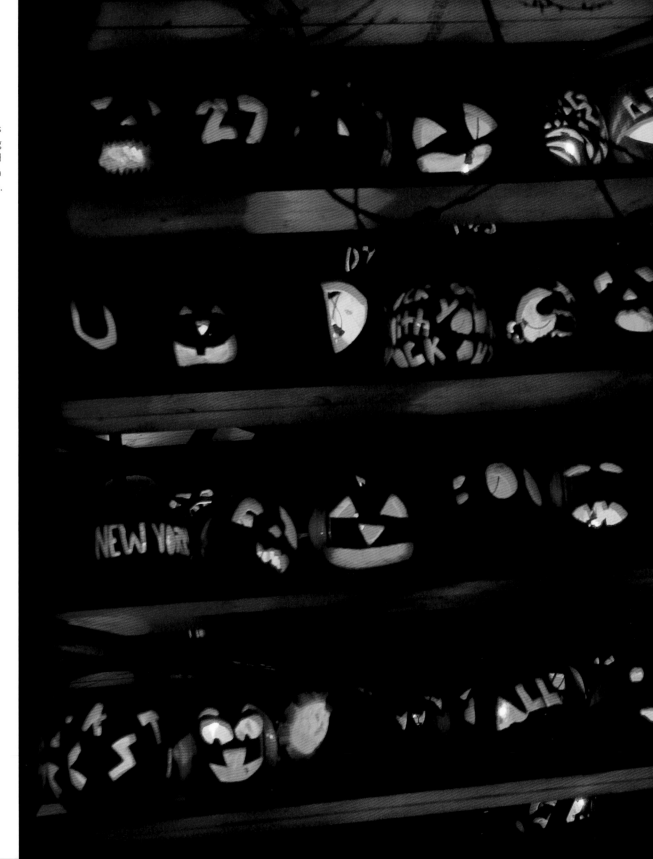

Rows of Jack O' Lanterns alit atop shelves along Main Street at the annual Pumpkin Festival, in Keene.

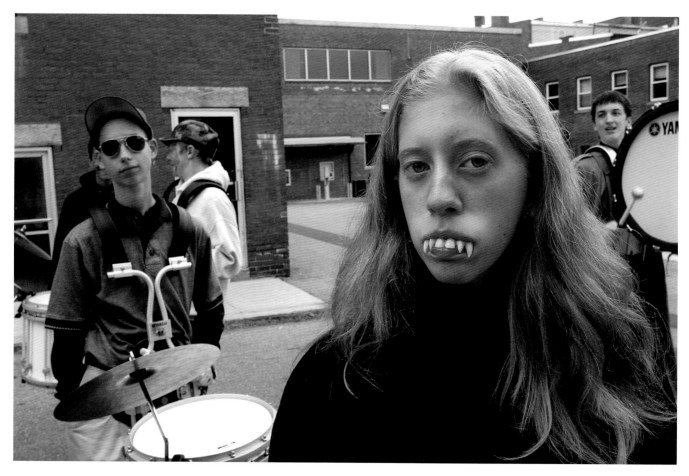

High School band members lining up for the Pumpkin Festival
Parade, in Keene.

Before the parade at the
Pumpkin Festival, in Keene.

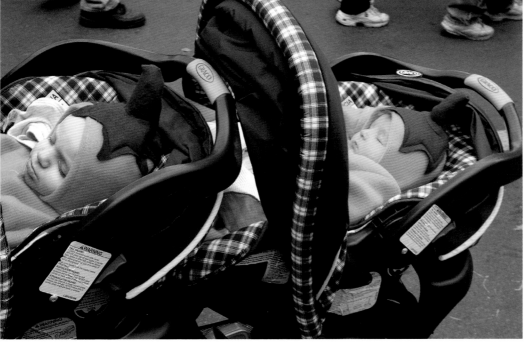

Participants in the Pumpkin
Festival Parade, in Keene.

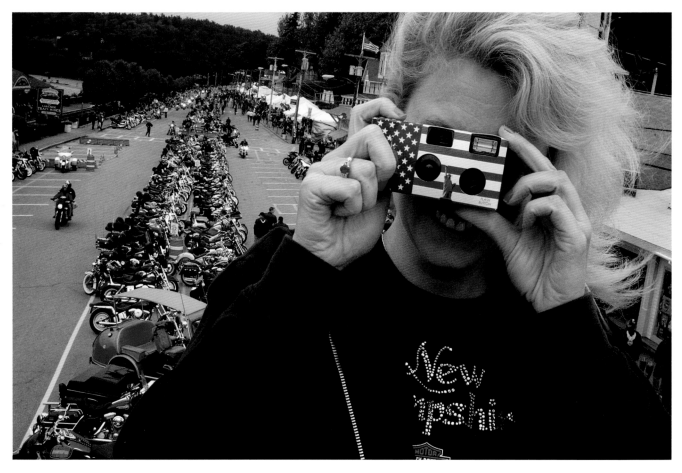

On top of the viewing stand at the annual Motorcycle Week, in
Laconia.

Motorcycle Music in a Cold Climate

It's the night before Memorial Day some time in the late 1940s. My father has dragged his family to a tiny, two-room cottage on a lake. He and my mom sleep in the bedroom, my brother and I in built-in bunks on the porch.

The lake water is still too cold for swimming; there's nobody else around; summer season hasn't started yet; there's nothing to do here. And then there's the noise of the motorcycles. All night long they pass by, on their way to Loudon and the annual motorcycle races.

It doesn't make any sense to come out here the night before Memorial Day, but my father insists year after year and he won't tell my mother why, though I suspect she knows. She puts up with it because she loves him and because he's not usually unreasonable.

I'm only a kid at the time, in the preferred top bunk, and the motorcycles are keeping me awake. The bikers usually travel in packs and when they approach on the state highway that runs right beside the cottage there's a gathering roar, like the sound of a huge breaking wave. I imagine the motorcycles crashing into the cottage. Surely, my parents will be killed, but my brother and I will be safe here on the porch; I figure that as orphans my brother and I will get more attention than we do now.

But the motorcycles miss the house, continuing on down the highway, and the sound changes to a low, fading moan, the lonesomest sound I'll ever hear.

Years later in school when I learn about the Doppler effect, how when waves of light or sound change as they pass by, I'll think about that sound of motorcycles approaching, leaving, fading. I'll think of my father. The reason he came to the summer cottage for Memorial Day weekend was not to be near the lake—it was to be near the highway. The Doppler effect of mo-

torcycles was his music: a dirge to mourn the friends he lost in motorcycle accidents, a dirge to mourn his youth.

As a boy I knew my father as a quiet, reserved, hard-working man and a very careful driver of our Chevy coupe. But it wasn't always so. As a young man, he didn't have a car. He got around on an Indian brand motorcycle, a huge machine, raw and unadorned.

After my mother decided at the last minute not to take her final vows as a nun and left the convent (because, she realized after two years in the convent, she wanted a family), she trained as a nurse and eventually took a job as a nanny for a wealthy family in Dublin.

The mansion where she lived on the third floor with other servants overlooked Mount Monadnock. It housed two families; it was so big and grand that one guy's only job was to polish things. My mother had a friend, an upstairs maid. One afternoon on my mother's day off the boyfriend of the upstairs maid showed up with another guy. They were both on motorcycles. The other guy was the man who would become my father.

My father used to ride with three other motorcyclists. They raced their bikes on a dirt track at the Cheshire County fair grounds. My father was sponsored by Zimmerman's Sporting Goods store. The best he did in five years of racing was a second place. The prize was two spark plugs.

By the time my father reached his mid-twenties, he'd lost his job and his three riding buddies, all of whom had been killed in motorcycle accidents, and he was living in Claremont with friends on a subsistence farm. The Indian had a broken headlight, and my father had no money to fix it.

He received word that a job in his former workplace had opened up. He spent the last of his few pennies putting gas in the tank of the Indian. He left before dawn, no headlight, and drove the forty-something miles from Claremont to Keene in the dark and cold (he had no winter gear). He arrived half-frozen, but he got the job.

A year later he married my mother. It was time to settle

down. My father sold the Indian and bought the Chevy coupe.

My mother pretty much runs the household. My father rarely says much. He goes along with whatever she decides; she has an education, he doesn't. But every once in a while he gets an idea in his head. And that's that—no arguments. And so it is one Memorial Day when I'm four or five. My father suddenly announces, "Let's go for a ride."

It's a tight squeeze in the coupe, which has no rear seat. My father is behind the wheel, my mother in the passenger seat with my baby brother on her lap, and I'm on the shelf between the back of the seats and the rear window. Not much wiggle room, even for a five-year-old.

After fifty miles of driving my mother finally asks the big question, "Elphege, where are we going?"

"To see the motorcycles," my father says.

We don't go to the races, we just cruise the streets.

My father says hardly anything. Just looks at the machines. Meanwhile, my mother is people-watching. A few years later there will be a movie called *The Wild One*, starring Marlon Brando, that will put motorcycle-America on the map, and make the leather jacket a symbol of danger and rebellion. New Hampshire is way ahead of the times. Everyone is wearing leather, many with club insignia.

I buy my first motorcycle when I'm twenty-five after I temporarily leave college to travel. I end up in New Orleans where I work as an attendant in a mental hospital. I buy a tiny, 100 cc twin-cylinder Yamaha, nothing like my father's huge Indian, but it's reliable and it gets 95 miles to a gallon of gas. It's perfect transportation for city-driving in a warm climate.

After seven months, I decide to return home to New Hampshire to finish my schooling. I arrange to meet my friend Bill Sullivan in Laredo, Texas. He's finishing up a stint in the Peace Corps in Venezuela.

Bill flies to Panama where he buys a 90 cc Honda and makes his way across lousy mountain roads for our rendezvous. He's quite a sight: big, red-haired guy on a minuscule Japanese motorcycle, arms black and blue from taking spills. Bill and I head for New Hampshire.

My scariest moment is crossing a steel grate bridge a hundred or so feet above a river, speed creating the illusion the grate is not there, and I can see the river far far below. I have a morbid fear of heights, and it's raining, and the Yamaha slips and slides on the wet steel, and passing cars throw up a mist in my face. The only thing I see clearly is the chasm under my feet. I puke, which flies back in my face. When we get off the bridge I look for a place to kiss the ground in gratitude, but traffic doesn't allow. We go on.

Adventure over, back at college in New Hampshire, I seek a bigger, more powerful me. Not likely, I think. I'll have to make do with a new motorcycle. The three S's of motorcycle shopping are styling, speed, and sound. For me the most important is sound. The Yamaha has too good a muffler. It is not loud enough. Its two-cycle engine creates a delicate whine.

Even the big Yamahas whine when they are revved. I do not want a whine. Honda sells a machine that is big and powerful, but the sound is too muffled and prissy and well-behaved, like a sewing machine. I do not want well-behaved. I do not want a motorcycle that sounds like a sewing machine. The German bike BMW has a great reputation, but it sounds like a car. Who wants a motorcycle like a car? If I want a car, I'll buy a car. Such are my arguments as a twenty-something male.

Harley—now there is a machine that makes noise. The top of the line Harley, known colloquially as the Hog, makes a throaty roar, like a dragon clearing his phlegm. Unfortunately, the Hog costs way more than I can afford, and it fails on styling; it is too gaudy and comfortable looking, a motorcycle for old guys. In my view, that's men over forty.

The Harley Sportster gets an A+ on styling, speed, and sound. It's roar is downright beastly. If you had a football team of motorcycles, the Hog would be a down lineman, and the Sportster would be a linebacker. My little Yamaha would be a place kicker. The Sportster is not as expensive as the Hog, but it is still out of my price range. Actually, a Schwinn is out of

my price range. But never mind. I am shopping for a motorcycle here. Price range means every dollar you have and all you can borrow.

I never seriously fantasize about a Harley, or any American bike, or a Japanese bike or a German bike or an Italian bike, though I do like the Ducati for the sound of the word—Du-kah-tee. What I want, what I daydream about for hours on end is an English bike, a BSA or a Triumph, and never mind that British motorcycles have a bad reputation for reliability.

I find the machine for me. It's a quirky thing, a BSA Victor, a single cylinder 441 cc thumper, a cross between a dirt bike and a street bike, a muscular but compact machine, visually distinct from all other motorcycles by its small, yellow gas tank. I love that gas tank. If a Victor were a football player it would be a fullback. When I hear the Victor on the street I shut my eyes. It's as if I were listening to the sound of a waterfall, the sound of a heaven for guys.

I can't afford the Victor, but I buy it anyway. It will be the most exciting and discouraging major purchase of my life. The Victor is all that I ever dreamed of. It's perfectly balanced between my legs; upon acceleration, it's so powerful I can feel the G-forces in my spinal column. Too bad it won't start half the time. It needs a mechanic to keep it running, and I'm no mechanic. At one point, I drive across country in my car, carrying the Victor on a trailer. I'm gone all summer and not once does the Victor start.

The following year I get married, and my bride and I move into a renovated barn in Nelson. It's a late spring day, a day to smell the lilacs. I'm working a night shift at a gas station in Keene, twelve miles from my barn home. Through the night, the temperature plummets.

By the time I leave work, it's forty degrees colder than when I arrived. I'm only wearing a light leather jacket over my street clothes. At first I'm merely chilled, and then I begin to feel numb. By the time I'm home, I'm shivering violently. I'm not sure I can make it on foot to the door. My wife, my beautiful young wife, holds me in her arms, warms me, saves me from myself. I will sell the Victor. I will grow up. Maybe. Years later it all comes out like this:

HYPOTHERMIA

You found me on the roadside on the frozen ground,
my machine still warm to the touch.
You stripped me to my underwear,
You undressed. Crawled into the sleeping bag with me.
I heard you talk
about looking at the sky through hardwoods
bare of leaves. You told me how nice it is
when the wind sends tremors through the tops
of the trees and underneath it's still.
You were talking to the New Me,
but I was watching the Old Me.
He sees his dead parents on an Indian motorcycle,
his father at the throttle, his mother on the saddle
behind him, holding on. The Old Me hears
the Indian now coming toward the New Me,
its gathering roar,
my mother and father vanishing
onto a highway going maybe to
the Loudon Motorcycle Classic
and then it passes, fades, the lonesomest
music I'll ever hear.

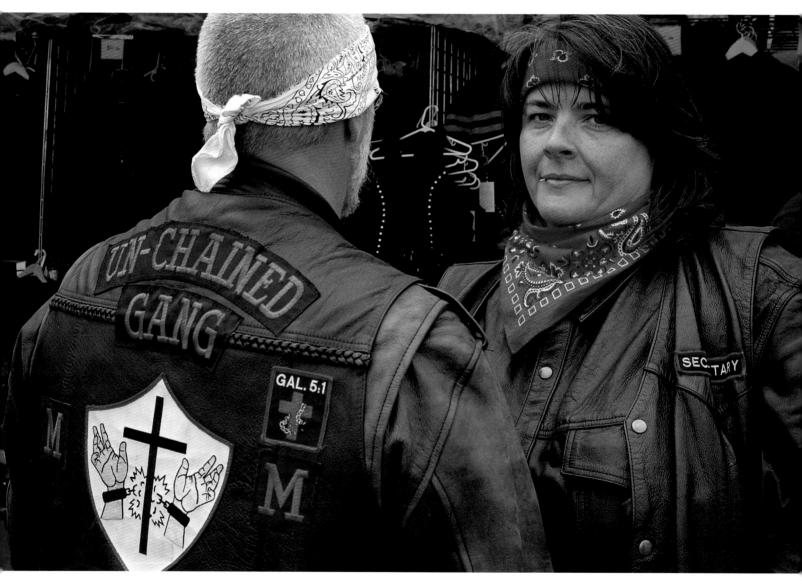

At "Bike Week," in Laconia.

The center of " Bike Week," in Laconia.

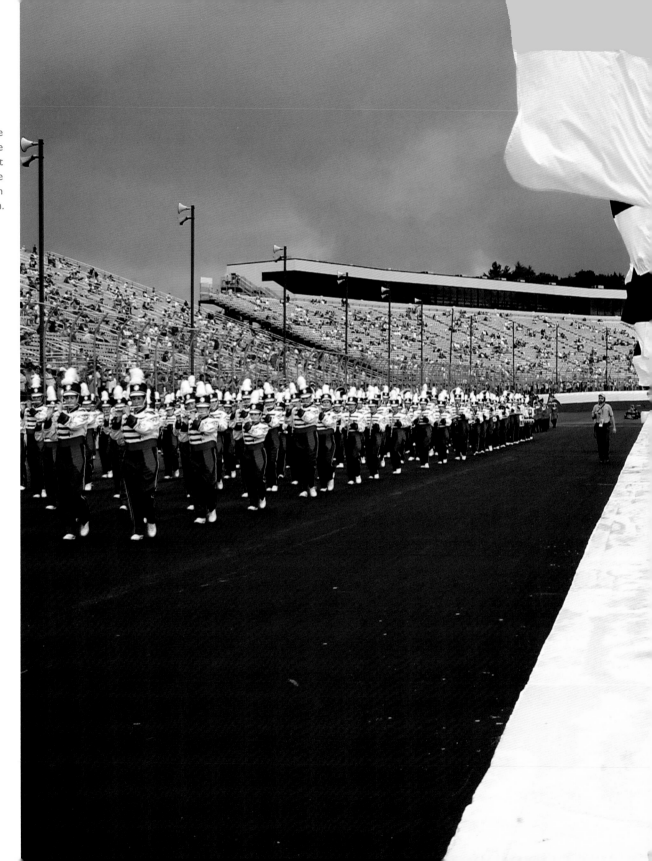

The band and the cars lined up before a NASCAR race, at the New Hampshire International Speedway, in Loudon.

58

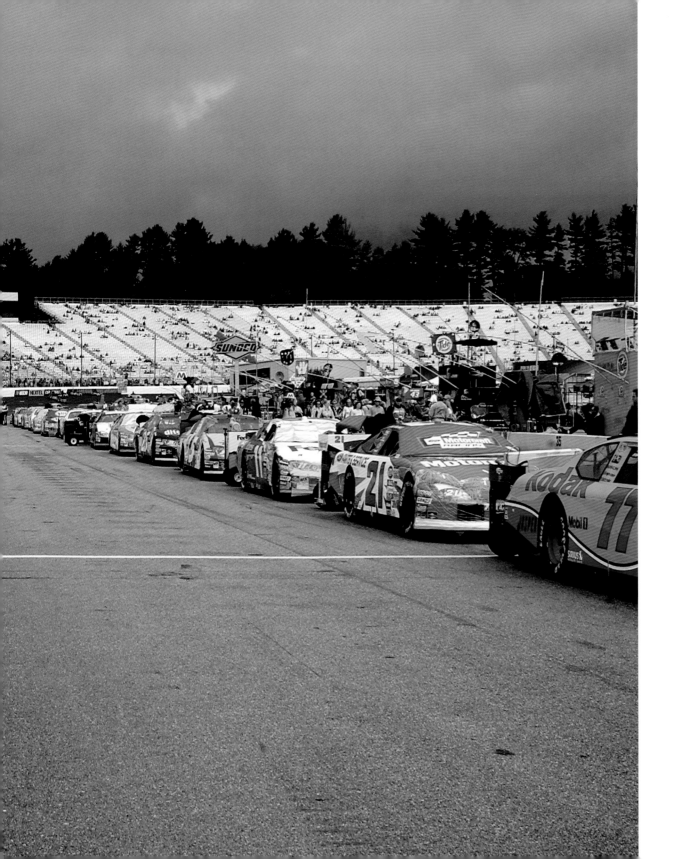

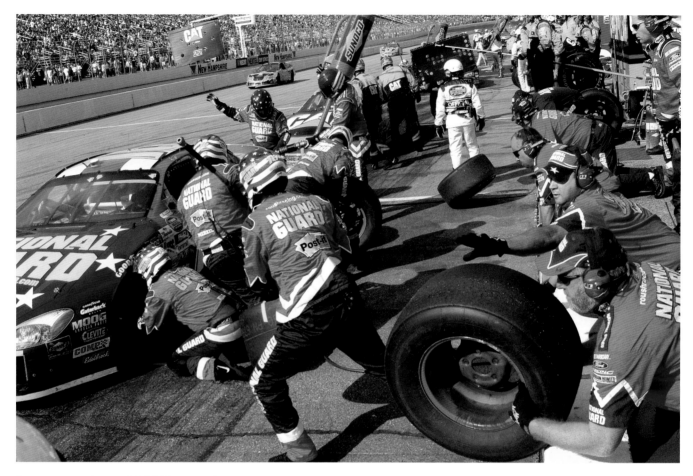

Pit stop action during a NASCAR race at the Loudon race track.

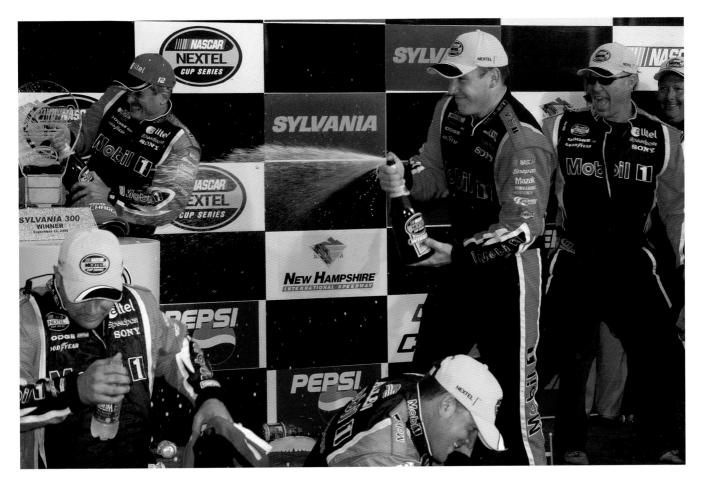

The NASCAR winner's circle, in Loudon.

A street scene during the annual Moose Festival, during the summer,
in Colebrook.

A Stranger in Town

As I write this in the first decade of the twenty-first century, it's not unusual to see a moose. Indeed, they're all over the place, so numerous that the state puts up signs, Moose Crossing. But in the 1970s moose were rare, except in the northernmost parts of the state.

So I was shocked one morning while driving to work when a moose stepped over the curb on Main Street in Keene—long, ungainly legs, thick dark brown body, a few chin whiskers, rack broad enough to envelop a VW bug—and began jaywalking to the other side. It's quite a sight to see a moose in the wilds, takes your breath away, but to see one on a city street is to make you question your eyes and mind.

I pulled to the side of the road and got out of the car. It was 6:50 A.M. There was a lull in the traffic and I found myself all alone, me and the moose. He suddenly turned toward me, ambling casually in my direction. I stood there awaiting my fate. The moose walked right on by, and then he turned and continued to cross the street.

He disappeared behind a Keene State College building about the time that normal car traffic resumed. It wasn't until the moose passed by close enough for me to smell his swampy BO, look into his large, sad eyes, and I had to resist the urge to reach out and touch him, that I understood what it meant to feel blessed. I wanted to tell the world that I had seen a moose. And I would. Because I was a reporter for the local newspaper.

I hopped into my Ford Pinto and drove off much too fast headed for the newspaper office. I burst in and without seeking an okay from my editor announced that I had seen a moose and intended to write a news story about him.

A minute later I was out of the building with my note pad in hand and pencil behind my ear, but I was not alone. Another reporter, Dayton Duncan, grabbed a camera, and the two of us went moose-stalking.

He was not difficult to find. We just followed the crowd, which led us to the Ashuelot River where he crossed Winchester Street. The bridge divided the older part of Keene from the newer. On one side were small, locally owned businesses and residences; on the other was a McDonald's and a shopping center. A police officer stood beside his cruiser with arms crossed. A score or more people paced on the sidewalk.

"Where is he?" I asked the cop.

"I don't know," said the cop in a tone that told me he didn't like being approached. His surly demeanor ran counter to the buoyant mood of the crowd, and I did not like him.

"Hey, look—there he is," a woman shouted. The crowd murmured.

The moose had just come out of some trees down by the river. He started walking toward us. A few people scattered. Others held their ground. Duncan crept closer with the paper's ancient two and a quarter Rollie, no telephoto lens. Other people with cameras aimed and shot. You have to marvel at the way amateur photographers jut out their pelvises when they peer through the lens.

The moose came on and the cameras clicked away.

I grabbed my pencil and started writing a description of the scene, jotting down lines I overheard from the crowd, lines like, "Hey, is he big, or what." The moose kept coming forward and then an idea seemed to dawn on him. I almost expected him to pull at his goatee in Socratic contemplation. He stopped, looked around, and turned back. He didn't exactly run away, but his gait, in retreat now, had lost its savoir faire. He went back into the trees. No one went in after him.

It was a very small stand of trees, maybe an acre in size, having survived in a natural state because it was in a flood plain. Behind it was a ball field where more onlookers had gathered. It dawned on me why the police officer was so surly. He had figured out from the start that humanity would trap the moose. A half an hour went by and during that time everyone knew what the cop knew: we, who revered this great animal, had imprisoned it by our human curiosity. Everybody

wanted to see the moose make his exit. The crowd grew to maybe fifty or sixty.

Word spread that someone from the state's fish and game office was on the way. What his role was no one knew.

"Maybe they're going to tranquilize him," a woman said.

"Then what? It would take a crane to lift him," a man said.

Time went by, and some people left but others took their place. By 10 A.M., no one had set eyes on the moose for more than an hour, nor had anyone gone into that small island of trees to check him out. I had to return to the newspaper to write the story for today's paper. My copy deadline was noon.

I hurriedly wrote up what I had seen, finishing around 11. I then called New Hampshire Fish and Game. The official there put a twist on the moose story that I had not expected. Crazy moose were part of a complex drama in Nature involving deer, tiny snails, and a brain worm.

I was surprised to discover that moose, not the more numerous deer, are the natural ungulate of the state. Moose are better adapted for survival in the North because of their greater size, which means they retain warmth better than the smaller deer. Their longer legs and splayed feet allow them to get around better on snow, and their strength and size better prepare them to fight off predators.

At one time moose roamed the state at will, and deer—a creature natural to the south lands—were not found this far north. What happened to change the ecology? The answer lay in a small, innocuous snail and meningeal parasites carried by the snail, which are accidentally consumed by ruminants as they browse in the wilds. The infected animals expel the parasites in excrement, where they latch onto snails and the cycle starts all over again.

When deer started making their way north, they brought with them the brain worm, to which they had built up an immunity. Moose, however, were killed by the brain worm. Result: Where you had a large deer population, you had few moose. In recent years moose, like deer, have also built up an immunity to the parasite. Result: more moose.

But back in the 1970s, moose were rare, and the one that jaywalked Main Street in my home town was likely a wanderer from the North infected with the brain worm.

Crazy moose are common. There's a documented case in Coos County where a moose charged a train, derailed it, and ran off a fair distance before keeling over dead. Irate farmers have reported bull moose attempting to round up dairy cows for their harems. It's such stories that have given moose the reputation of being stupid and comical. In reality normal moose are as prudent as any wild animal. The crazy moose, the Bullwinkles of the natural world, are likely brain sick.

The 1970s moose story ended in a mystery. The next day I did a follow-up. Despite scores of people surrounding the moose by the river, there were no reports that he was seen again after he went into the small copse of trees. Nor were there later moose sightings phoned to the police or the newspaper. How did the moose get away without being seen? Why was he never seen again? Where did he go?

Maybe the moose in our midst was visited upon us by those forces of Nature that we call God to manifest our collective guilt for screwing up the world environment, or perhaps conveying some other message that I'm too stupid to understand. Or maybe it was a case of mass hysteria: we all saw the moose but he was never there. More likely he was there and sneaked off in the middle of the night to search for a private place to lie down and die far away from home. All I know for sure is that I think about that moose often.

Near Stratford.

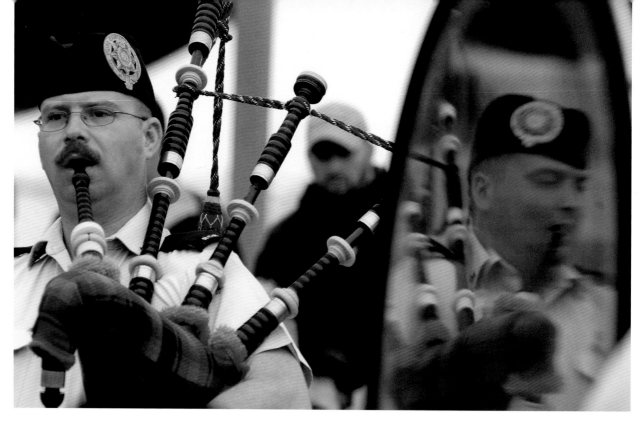

Piper at the
Scottish Festival, in
Contoocook.

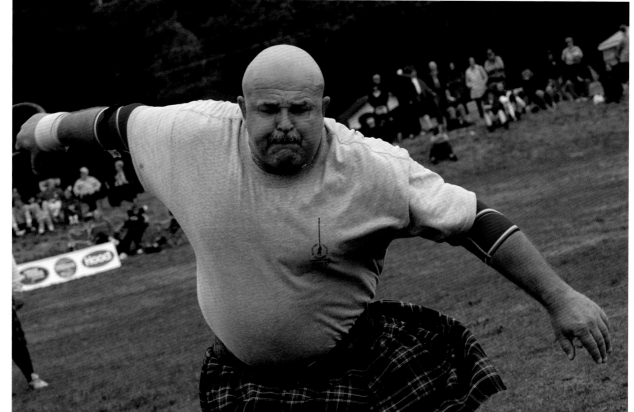

Competing in new
Hampshire's oldest
Scottish Festival, in
Contoocook.

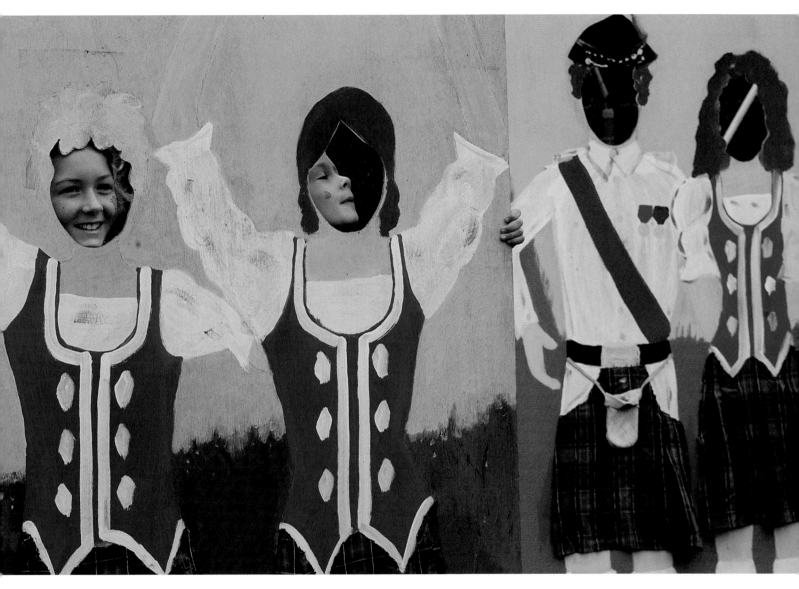

At the annual Scottish Festival, in Contoocook.

The bonfire at the annual Dartmouth Night at Dartmouth College, in Hanover.

Facing page: A fishing boat returns to the Portsmouth harbor.

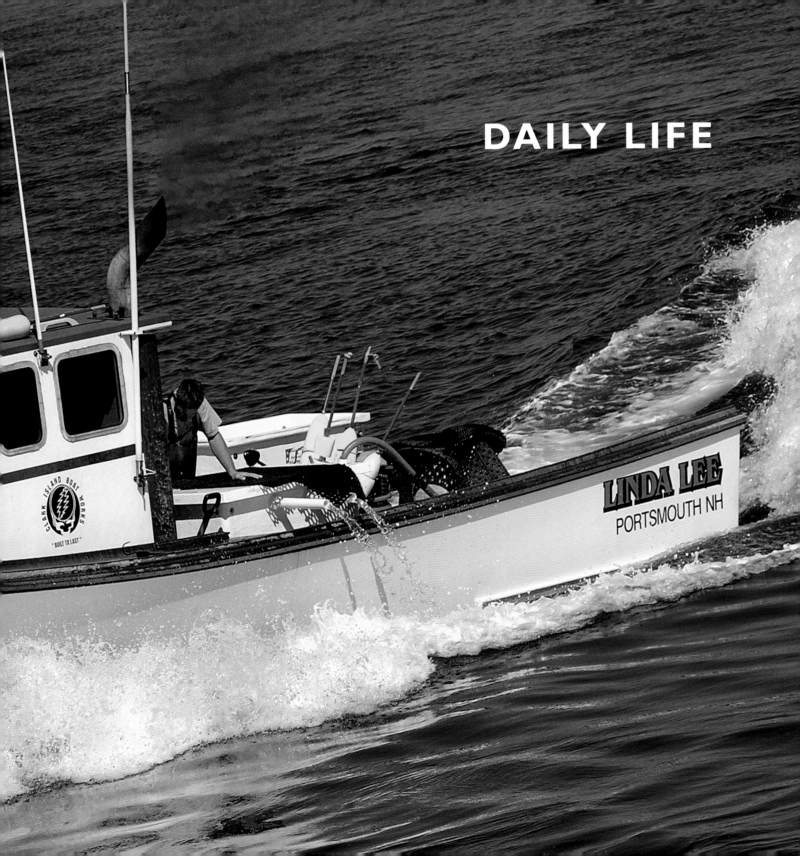

DAILY LIFE

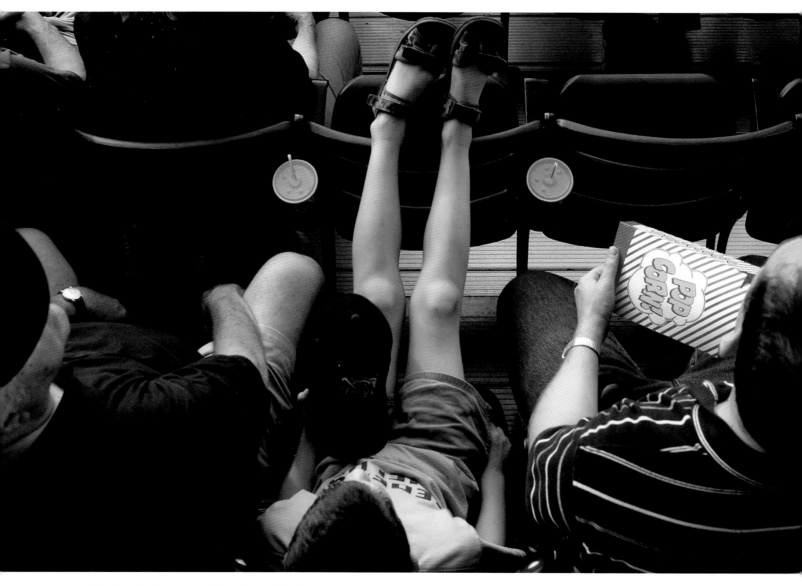

Watching the hometown Fisher Cats, in Manchester.

Dream of Fields

I was in my late fifties batting at Len Fleischer's annual Old Farts Softball Game. We were playing on one of the fields at Wheelock Park in Keene. You would not say that the grass was "manicured," nor the dirt on the base paths perfectly level and raked, nor the chalk lines bright and straight (there were no chalk lines). Even so, it was one of the best fields I ever played on. It had a real home plate, real bases, a real pitcher's mound, and an accurate diamond lay out. Most important, it had a real home run fence.

I was thinking how much I liked the field when the pitch came in, one of Len's medium speed floaters in the middle of the plate. I don't remember swinging, but I remember the feeling in my hands when the aluminum connected with the imitation horsehide. At that instant I knew it was gone. I stood, watching the ball rise nice and quick in a howitzer-like arc to left field, then falling a good thirty feet on the other side of the fence.

It was the first time in more than fifty years of ball that I'd hit one over a fence, because few of the fields I played on had fences, and anyway I wasn't much of a home run hitter, except for dreaming about it, which I was pretty good at. I started my home run trot down the first base line, and then I got an idea inspired by my childhood hero, Ted Williams, who had hit a home run in his last at bat.

I touched first and kept right on slowly waddling down the right field line, past the fence, and into the parking lot. I got into my car and drove off, a man content with his accomplishment. I haven't played a ball game since and do not intend to. I can always say that like Ted Williams I hit one over the fence in my last at bat.

The first ball field I played on was Oak Street in Keene where I grew up. It was a narrow street with only local traffic. There were no oak trees on Oak Street. Myself, my kid brother Omer, Skook McCollester (my "best friend" and the president of our "club") and Skook's kid brother Donny, and sometimes Scott Collier and the Bemis boys, Ronnie and Skip, managed to play baseball and football on that little street. More than once I made the mistake of actually sliding on the asphalt.

I came to think of scrapes on elbows and knees as body art. If a scrape didn't bleed, it wasn't worth much. The best scrapes included asphalt encrusted in the wound because of the yellow puss days later. The best part was the scab, the thicker the better. You picked it off and chewed it. The thrill wasn't the bland taste; it was the crunch. You spat it out when it softened. The best scrapes left scars.

As we grew older, we moved our games to Mike Saunders's yard on Grant Street. His family had something that the Heberts, McCollesters, and Colliers did not have, a grassed yard big and flat enough to play ball on.

One Christmas I received a kids' printing press, and Mike and I made flyers that advertised the Mike and Ernie Detective Agency. We stuck the flyers in people's mail boxes all along the east side of Keene. We got in trouble but it was worth it. It was my literary debut.

Around age ten we were old enough to walk up the steep hill to Robin Hood Park, where the city provided us with a real field. Well, sort of.

The field was built right below the dam of the park pond, a reservoir that everybody called "The Rez," and it had grass mixed with dandelions and other delightful green things. Left field ended abruptly at a steep, wooded hill. No fence.

In right field, further away than any of us could reach with a hit, was a playground and tennis courts. None of us ball players would be caught dead in the little kids' playground if there were peers in the vicinity, but if you were alone it was okay to reach back into the vast distance of your childhood and go down the slippery-slide or pump hard on the swings and jump off at the top of the swing and leap into space, falling in the sand below. Stunts like that cost me a broken arm

at age seven (playing king of the hill in the snow) and a dislocated and broken wrist at age fourteen (leaping from a height at a construction site and breaking the fall with my hand).

One year at Robin Hood Park field, somebody stole home, that is, stole home plate. After that the city stopped maintaining the field and today at this writing it doesn't even have a backstop.

In eighth grade I joined the CYO (Catholic Youth Organization) baseball team. We played our games on a practice field at Keene State College. The outfield melded into a soccer field. No fence.

We were playing a team from Winchendon, Massachusetts, when I hit the ball as far I was capable of. It was caught by the left fielder. It didn't disappoint me that I had made an out: I made lots of outs. It didn't disappointment me that I'd let my team down. None of us really cared if we won or lost—we just wanted to play—and it was only later that winning would be everything. What disappointed me was that I had done my best and it was not good enough.

The experience gave me a glimpse into the adult world that lay ahead, cold and unfair, where you were a winner or a loser, and playing for the pure joy of exertion was, well, childish. I was frightened. You could surpass your expectations, do better than you thought possible, and still be crushed. It was my first encounter with existential angst.

When I was nineteen I worked for the telephone company on weekdays. But on summer weekends I rode the bench for the Munsonville village baseball team, occasionally pinch-hitting or playing second base or right field when our coach and star pitcher, Joe Dobson Jr., took pity on me and let me in late in a game.

Our home field was literally a cow pasture with a distorted diamond that followed the shape of the pasture. Base paths were regulation distance, but angles between the bases varied greatly. There was no pitcher's mound. You could be running down a fly ball and suddenly find yourself in muck, or you might run into a tree inconveniently located in shallow right center.

The most dramatic feature of the field was a boulder in the shortstop position the size of a Lincoln town car. A line drive that caromed off the boulder and went into foul territory (thick with bushes) was a ground-rule double.

I went back a couple years ago, and I think I found the field even though houses have been built on it and the landscape has been rearranged, because I recognized the boulder: still a menace, still a symbol, still an experience—something; I wasn't sure of the philosophical import, but I was glad the boulder was still there and will be there long after I've departed from life on this planet.

One field that vanished from the planet was Norman Arsenault's yard on Winchester Street in Keene. In seventh and eighth grade, we boys from St. Joseph Elementary School played tackle football in that field on weekends. Beyond the yard was a meadow and then a marsh and finally West Hill. It was a pretty spot. Today the entire area is a generic-America shopping center, the original landscape not just altered but obliterated. House, field, meadow, etc.—gone.

St. Joseph's school had a nice, big playground for grades 1–6. We seventh and eighth grade boys turned the church parking lot beside the school into a playing field, baseball in the spring, football in the fall. There was no grass but no asphalt either. Just dirt. In the winter, we played king of the hill on the plowed snow banks. (Note that this was a time when girls and boys were segregated, in the classroom and outside at recess. The girls' play area was considerably smaller than the boys'.)

The parking lot field had a fence, but I never hit one over it. I did break a window in the school with a line drive foul ball. In fact, I was trying to pull the ball on the roof of the two-story school building. Behind the fence was the convent where the Sisters of Mercy, our teachers, resided.

One winter we had a thaw that melted all the snow along with a heavy rainstorm that flooded our field. Next day a cold

wave came in and froze everything solid. The field was a sheet of ice. We were not allowed to go outdoors during recess, and I stood by the window of my second-floor class room gazing out and wishing I was on the ice.

I watched two nuns walk from the convent toward the gate and the frozen parking lot. They were easy to spot, because in those days they wore traditional habits, long black gowns and black head dresses.

One of the nuns appeared to be hobbling, the other helping her keep her balance. I recognized the hobbling nun as Sister Charles. She had been my favorite teacher in third grade. I was in eighth grade now, but I still liked her. I worried that something was wrong with Sister Charles.

The moment Sister Charles placed a foot on the ice she began to glide. Very suddenly she was moving at great speed. She twirled and spun, and glided some more. It took me a while to figure out that she was wearing ice skates.

The sight of Sister Charles in full nun's habit moving swiftly and gracefully on the ice filled me with an emotion that I had never experienced before. I wanted to weep with joy, but of course I did not.

I nurtured that emotion for days, replaying the mental movie reel of Sister Charles on the ice over and over again. I didn't tell a soul, though I wanted to; I was afraid if I told anyone it would break the spell and also that it was somehow wrong to be so happy. When I saw Sister Charles in the hallway I couldn't bear to look at her because she was so beautiful. It wasn't until years later that I realized what I had experienced for the first time: the feeling of falling in love.

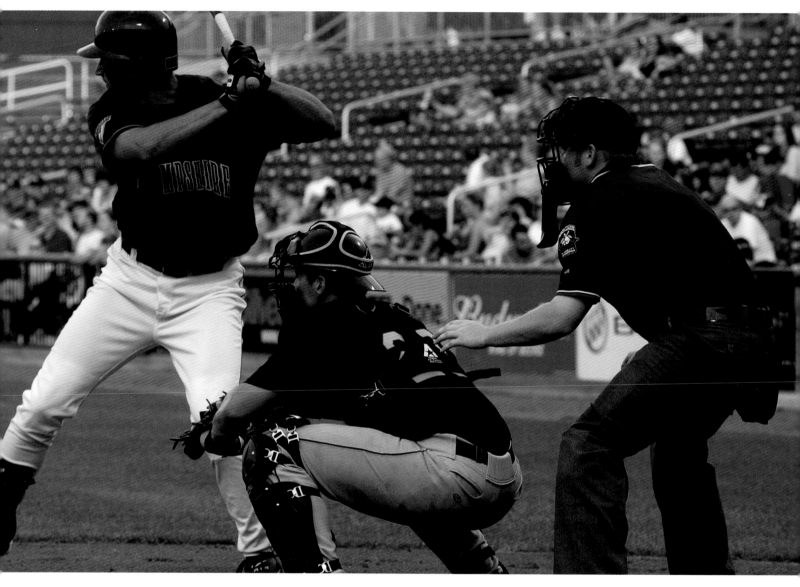

Down on the field with the Fisher Cats.

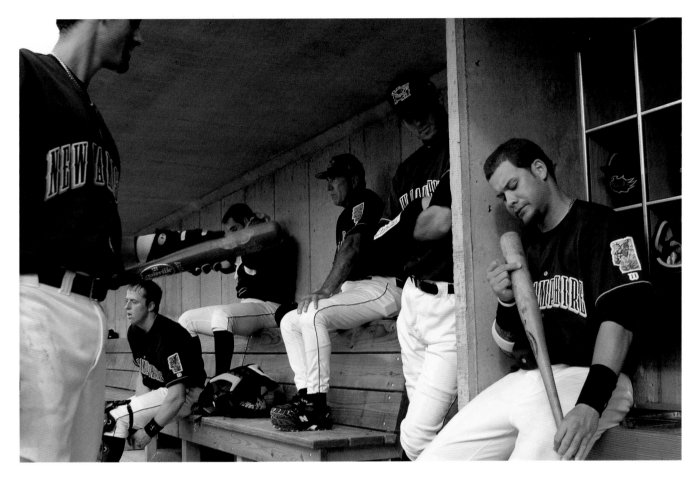

In the dugout of the Fisher Cats baseball team, in Manchester.

Along the road.

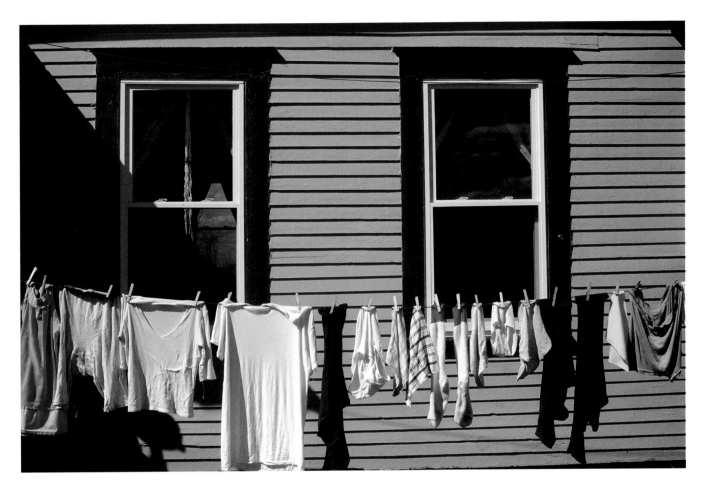

Colorful laundry near Piermont.

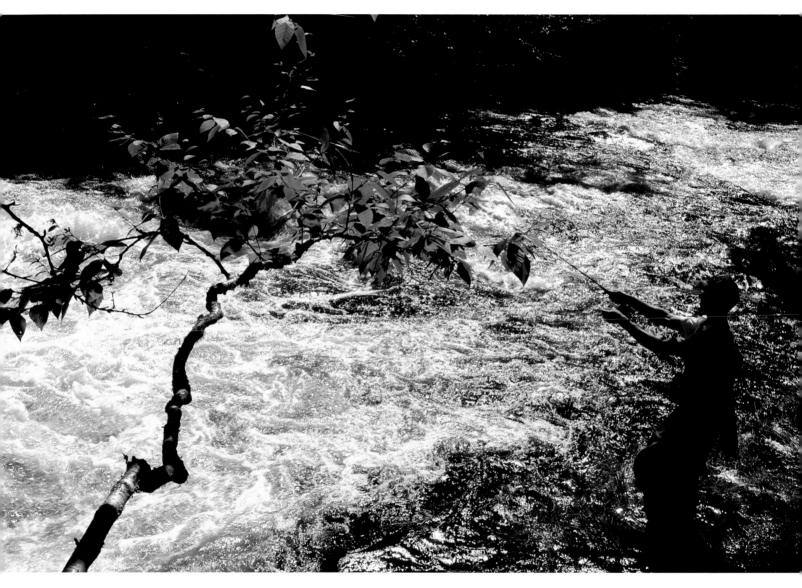

Fishing below a dam between the Connecticut Lakes.

Confessions of a Recovering Fly-Fishing Addict

As a kid I fished with worms, and I caught undersized perch, pumpkinseed, an occasional small-mouth bass, hornpout (a.k.a. catfish), and suckers (a.k.a. carp). Fishing was not a big deal. It was just one more thing I did in the outdoors.

One summer when I was about thirteen the Keene Chief of Police paid me a few bucks to take him trolling on my dad's boat on Granite Lake in Stoddard. He knew nothing about fishing and seemed to have no interest in catching fish. He just kind of daydreamed during the entire afternoon we were on the water. No doubt he was just happy to get away from a telephone, but at the time his behavior puzzled me.

On that day, trolling with a red and white striped lure called a daredevil, I landed the biggest fish I'd every caught. It was a yellow perch fourteen or fifteen inches long. I was disappointed that the fish did not put up a fight (perch rarely do), and also surprised at how good it tasted. Years later, I realized that perch might have set a state record.

Another time I caught a fair-sized trout about ten inches long and I experienced that thrill that fisherman seek, that fierce tug on the line that courses from your hands to your sternum, which triggers a reaction in the brain that is very very satisfying.

After I married at age twenty-seven I didn't do much fishing for four or five years, and then I discovered *Fly Fisherman* magazine. The layout, the graphics, the quality of the prose excited me. I was in love. Not with fly-fishing but with the idea of fly-fishing. *Fly Fisherman* magazine made fly-fishing seem beautiful and magical, even noble. I had to try it out.

I'm not one of those people who can learn things by watching other people, nor can I just do it. I have to read about it first, absorb the custodial knowledge of the experts and the elders. It's how I learned to build a cabin, sail a boat, accumu-late and burn firewood, and make a wooden spoon with hand tools; it's how I learned to fly-fish.

For equipment I shopped at Zimmerman's on West Street in Keene. The sporting goods store, in a sprawling wood-frame farm house, was one of the oldest businesses in the city. It was operated by John and Bill Zimmerman, men pushing eighty. I loved that store.

It was like being in somebody's old house with wavy wood floors, peeling, faded wallpaper. Nobody had dusted in a decade or more, and the merchandise lay everywhere without apparent plan. But it was all good stuff: looked like junk, but not junk. And John Zimmerman knew where everything was.

Bill Zimmerman was the mechanic in the family operation. You'd see him in the garage working on boat motors. In the Zimmerman's radio commercials, Bill was billed as "the young good-looking one."

The Zimmerman brothers sold me a relatively inexpensive fly-fishing outfit consisting of a Shakespeare brand fiberglass rod, reel, 7-weight line, leaders, an assortment of flies, a vest, and other paraphernalia. Shortly afterward, John Zimmerman died, the store closed, and the building was torn down.

As it turned out, the rig that the Zimmermans sold me was just right, and it lasted for years. It also turned out that my method of learning by books paid off. Following the instructions I'd memorized, I learned to fly-cast adequately if not expertly in a couple days.

I tried stream fishing, but I didn't like fighting off black flies and mosquitoes, and the sound of babbling brooks was a tyranny to me. I liked frequent periods of quiet, interspersed with the music of a breeze, the calls of birds, the yips of coyotes, and the slap of the tail of a beaver on the water as it dives. These are the sounds you hear on a pond. I soon became a pond fisherman.

Ponds are less crowded with human beings and boat traffic than lakes; ponds are all over New Hampshire (thank you, Mister Glacier); by the grace of New Hampshire law, ponds all have public access points to launch a boat; ponds are moody.

I like moody. If you want a glimpse into God's mind, visit a pond on a misty morning and just wait.

I bought a second-hand, ten-foot aluminum johnboat for $75, which slipped nicely into the back of my Datsun pickup truck. Over the years I must have visited more than thirty ponds in Cheshire County. My favorite was Bolster Pond in Sullivan.

Because it had no road around it and only one camp on the forested shore, and because it was miles from a paved road, it was quiet. Granite ledge and rocks jutted out of the water. I like rocks; rocks, unlike people, become prettier as they age.

Bolster Pond had an irregular shape that included a cove ending in a swamp with tall, somber, dead trees, on the top of which were huge nests built by great blue herons. I explored the swamp, using an oar to pole the boat, because rowing would make noise. I came upon a mother heron.

She stood perfectly still in about six inches of water for about twenty minutes, apparently just musing. I tried to match her stillness. It's difficult to remain still and observant. The muscles tense and the mind yearns to roam in the play land of memory and fantasy.

In a split second, her head bobbed into and out of the water. She came up with a perch about six inches long in her bill, and then she began the long, labored, and awkward take-off of a creature marginally built for flight. Once she was off the water, she became graceful, soaring on an air current, flapping her great wings. She flew almost to the end of the pond, gaining altitude as she went, and then she circled back to her nest in the swamp. I could see the open mouths of two rather large fledglings yammering for that fish.

I always caught fish on Bolster Pond—good-sized perch, an occasional bass or pickerel—all without trying hard or really caring whether I caught fish or not. I'd just drift around the pond with my line dangling in the water. With pliers I'd break the barbs off the hooks to make it easy to release the fish. My main interest was to put myself into the mood of the pond.

The only time I'd see anybody else on Bolster Pond was at dusk, when the hornpout fishermen would arrive just as I would be leaving.

And then—disaster! In 1979 I published my first novel, *The Dogs of March*, which gave me a little extra money to play with. I got rid of the johnboat and bought a canoe, a new fly rod and reel, flies, and various expensive accessories such as polaroid sunglasses and a fancier vest. I thought I looked peachy out there on the water.

I started fishing trout ponds, especially fly-fishing only ponds. If there's a more beautiful animal on the planet than a brook trout, or one that is more feisty, I don't know what it is; trouble is, trout ponds attract fisherman. When I fished I usually had company on the pond, annoying but bearable.

And then that damn movie came out based on the book by Norman MacLean, *A River Runs Through It*. I didn't see the movie, but I read the book. I hated the protagonist, who reminded me of me during my most selfish moments. Every time I heard somebody talk about *A River Runs Through It* I wanted to puke.

Not that it mattered what I thought. All of a sudden, it seemed to me that everybody was fly-fishing. The best trout ponds grew crowded with canoes and anglers.

I began to feel inadequate. Other fly-fishermen were better equipped. They had better rods, better vests, and longer canoes. They cast further, they caught more fish, and they seemed to know more than I. I responded as one to a challenge. I was determined to become a better fisherman.

Every spare moment I fished. In the off season I read pamphlets, magazine articles, and books on fly fishing. Occasionally, I'd catch a big fish and carry that rush of pleasure in my mind for days. If I caught more fish than my competitors on the ponds, I would feel superior. If I caught fewer fish, I'd feel inferior.

I dreamed of travels to Quebec and Argentina, where it was said huge trout awaited the expert angler. I lusted for more equipment and more thrills at the end of the tapered leader. I

fished so much that I developed tendonitis in my right arm—canoer's elbow.

Matters reached a head one Sunday afternoon when I should have been reading the Sunday papers or a good novel. Instead I was reading a magnificent tome called *Trout* by Ernest Schweibert. I was about halfway through the book, and I was writing on a notecard the Latin name of a bug that trout eat when it occurred to me that I'd pushed out childhood memories to make room for bits and bytes of fishing lore. It hit me: why the hell am I doing this? I slammed the book shut and decided never again to cast a fly on the waters.

I've been clean for fifteen years now. I've forgotten all those Latin names of bugs; I've forgotten what weight wet line to use casting nymph flies on a medium-size stream; I've forgotten

what an Adams fly looks like; my heart no longer palpitates at the sight of a Hardy reel.

In place of all that lost information, I've retrieved some childhood memories. I remember the bike ride I took with Ronnie Bemis, me operating the bike, him on the handle bars, the telephone pole we hit, him chipping a front tooth. Forty-something years later I saw him on the streets. We hadn't met in decades. He opened his mouth, smiled and pointed.

I remember picking white and purple violets for my mother and how years later just before she died she recalled those days when I picked flowers for her and she didn't have the heart to ask for longer stems so she could put them in a glass with water.

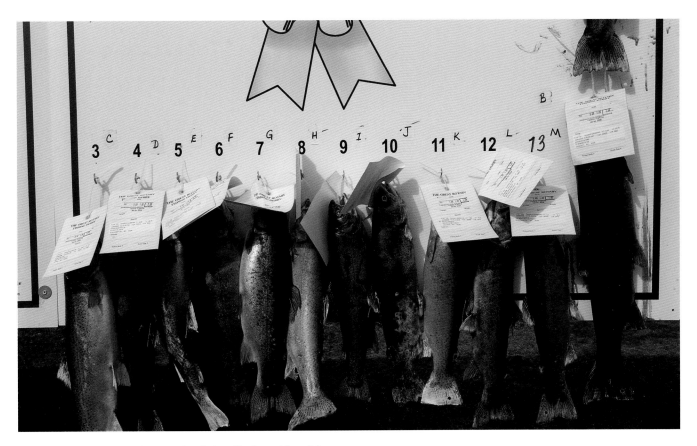

Some of the early results from the Ice Fishing Derby, in Meredith.

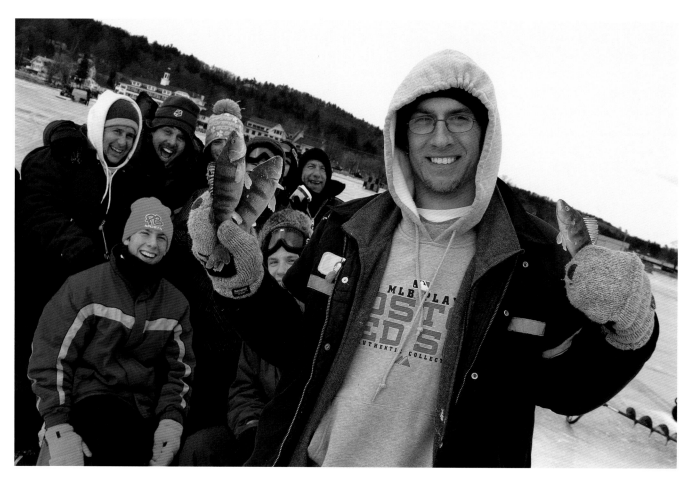

A group from Massachusetts shows off its morning catch at the
annual Ice Fishing Derby on Lake Winnipesaukee, in Meredith.

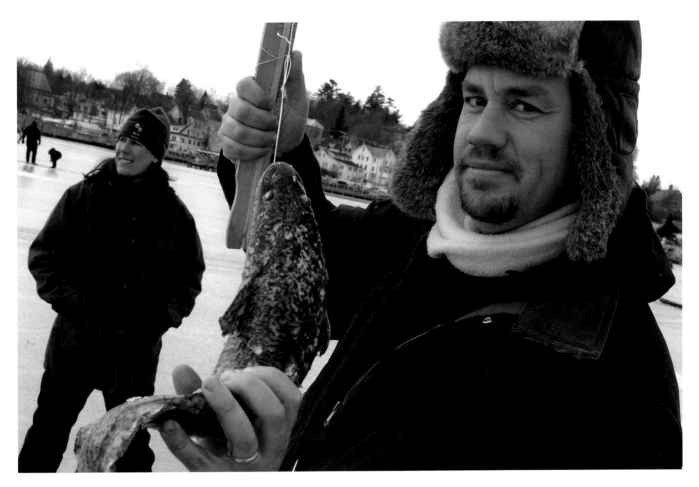

Husband, wife, and fish at the Ice Fishing Derby, in Meredith.

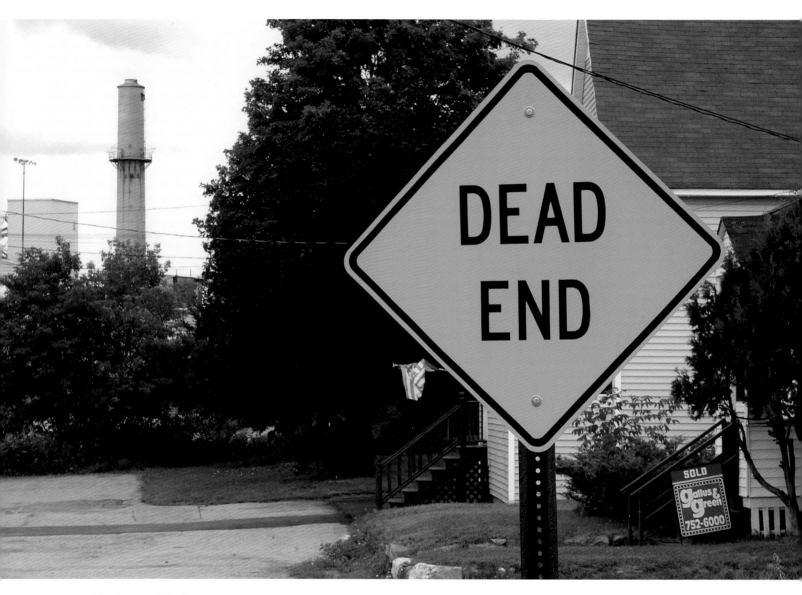

A back street in Berlin.

The Web Boy: Working in a Textile Mill

My father, Elphege Hebert, approached me a week before school let out for summer vacation at the end of my sophomore year in high school.

"I have something I want to talk to you about," he said in voice I found menacing.

I didn't know him very well in those days. We rarely saw one other outside of meals around the kitchen table, so when he asked to speak to me privately I was apprehensive. Had I done something wrong? Of course I had done something wrong —I was sixteen. How did he find out? But he surprised me.

"I imagine you'd like to earn some money this summer," he said in a tone I could not read.

I wanted to shout: Yes, I want money, I like money, money is freedom. Instead, I mumbled, "I would, yeah, I would." These were the 1950s when Marlon Brando and James Dean made mumbling fashionable.

"Good. I think I can get you a job at the shop as a Web Boy," he said. End of conversation.

The "shop" was a textile mill, the International Narrow Fabric Co. Inc. building on Congress Street in Keene, New Hampshire, where my father had worked for decades.

My father completed either seven or eight years of education. I'm not sure of the exact number, because he wasn't sure himself. He went to work in factories at age fourteen. Two years later he started at the International. He left briefly in the 1930s when his union went on strike. Six months later—broke, desperate, living off the land with friends—he returned to the International when management offered him his old job back at a reduced wage.

My father promised himself he would never again join a union, never again vote Democrat, never again leave his job. He followed through on all three resolutions. He stopped working at International Narrow Fabric Co. Inc. when he was

sixty-four and then only because the company closed its New Hampshire mill.

For most of the twentieth century New Hampshire had a dual identity. It was the land of *Yankee* magazine with picturesque farms, mountain forests, quaint villages with pretty town commons, Colonial-era houses, austere town meeting buildings, and grange halls. At the same time it was a small-scale urban industrialized society dominated by textile mills, woolen mills, paper mills, and shoe shops in Manchester, Nashua, Berlin, Keene, Claremont, and Laconia. The mill economy even reached into very small towns such as Harrisville.

Laborers came from impoverished Yankee farm towns, Europe, and French Canada. For fun my father learned from his fellow mill workers how to count to ten in Italian, German, Polish, Lithuanian, and Greek. He taught them how to count in French. For me the red brick shop was as much a part of my world as the big white Congregational Church at the head of the square.

As a kid I never had chores to do around the house. My parents believed that work life was so physically and mentally debilitating that children should be protected from it as long as possible. When I agreed to work a summer in the shop, it dawned on me that my childhood was over.

The reason I didn't see much of my father at home is that he worked ten hours a day Monday through Friday and five hours on Saturday, and he worked his fifty-five hours a week alternating day and night shifts. This cycle of work (and sleep deprivation) went on for more than forty years and often made him irritable, though he never complained—about anything or anybody. Which is probably the reason I never got to know him well until he moved into my house for a couple years until his death at eighty-eight. If a parent is not one to complain there is not much to say to the kids.

My father had long fingernails that he was careful not to break or mar, because he needed them in his work, but for what I did not know. He rarely talked about what he did dur-

ing all those hours he was gone, but he was proud to call himself a weaver. I wasn't sure what that meant. I had never set foot in the shop.

First day on the job, my father and I walked together from the parking lot. It occurred me that he carried his lunch pail in his left hand because he was left-handed and I carried my brown bag lunch in my right hand because I was right-handed. The observation made me feel alienated.

Even though we were still a hundred or more feet from the shop, I could hear the din through the open windows. It was a heavy, complex sound that included rattles, clicks, roars, whirrs, and what seemed to my paranoid ear the muffled wails of people being tortured. It passed through my mind that I was about to enter hell and I was afraid.

My fears did not ebb when I stepped through the doors into the huge open area that housed the power looms. The heat hit me hard enough to stop my breath, and I could feel the noise as vibrations rippling the concrete floor on the soles of my feet. At the end of the day, when I stepped outside I had the illusion that the ground was shaking, but of course it was only my body.

I didn't see my father at all that first day. A tall, dour man took me aside and said, "I'm your foreman, I'm going to break you in."

In the next few months, my foreman stalked me, but then again he stalked everybody else, too—that was his job. He criticized my work, but he was never harsh. He never raised his voice (except to be heard over the din), but he never smiled either. He spoke to me about my duties, but not about anything else. I never knew whether I liked or hated him, and I cannot remember his name.

My job as web boy was simple enough. The raw, unfinished product from the looms, called web, would automatically wind on a roll. When it was full, I would cut the web and wind it onto another roll with a hand crank. I would bring the web to a storage bin. From there it went to the "finishing room," where it was run through dye vats.

The only care I had to take was to keep my hands clean and the web from coming into contact with any grimy surfaces. My foreman warned me that dirty web could get a web boy in trouble.

The work was not hard, but it was tedious and the environs were nasty with heat, noise, vibrations, and dangers. Whirring belts and grinding metal gears the size of bicycle wheels (no guards) could chew off and spit out a body part, if you weren't careful. There was no ear protection. These were the days before OSHA.

What bothered me most was cotton lint floating in the air. It collected in little white puffs that dived and sailed on currents of heated air like dandelion parachutes until they finally fell to the floor, gathered, and rolled down the aisles between the power looms like tumble weeds on the streets of an Old West town. Even when you couldn't see the lint motes you could feel them like tiny worms burrowing under your skin, crawling up your nose, in your ears, and down your throat. In old age my father gasped from emphysema, and I blame forty-five years of cotton lint.

Occasionally, my foreman would order me to wheel a cart load of web to the finishing room. I'd leave the din of the great hall of the power looms, walk through the canteen and web storage, down a long, dark, hall, pushing the cart of web. The further away from the noise and vibrations, the better I'd feel. By the time I reached the finishing room it would be relatively quiet; the gentle noises of the finishing room were soothing, clicks and hums and sad romantic sighs.

With its steaming dye vats the finishing room felt like a tropical rain forest. The heat and extreme humidity made me dizzy and a little sleepy, an oddly sedative affect. The floor did not shake and my sweat pores opened and flushed the lint crullers from under my skin.

The long strips of white web appeared alive as they snaked through a series of rollers before they entered the dye vats, which resembled witches' cauldrons from old books, and then slinked out in various colors onto drying racks. Surely

my memory, though vivid, is flawed when I see peculiar light in the finishing room, like the last of a lurid sunset, colored vapor rising off the dye vats. On a platform high above me sits the finishing room's only workman, in a white uniform such as a cook or hospital orderly might wear. He's plump and constantly wiping his glasses, which keep steaming up, and he is happy to see me and his last name is Flagg.

My job is merely to deliver the web and be gone, but Flagg greets me and engages me in conversation. I'll linger as long as I dare. In the relative quiet of the finishing room, we can actually converse. Flagg was a weaver once but he volunteered to man the finishing room, a job nobody else wanted because of the heat, humidity, and isolation.

Flagg was a hero to me in a way I could not have explained at the time. I think now that I admired him, because he chose to cut himself off from his fellow workers in return for limited autonomy. The echo of his voice in that high-ceilinged room, the serpentine web in long strips going into the dye vats, the strange light, the play of white against colors, and the cleans-

ing heat—it was all so beautiful and magical for me. I never had that experience again until I spent a summer night on Magazine Street in New Orleans years later.

After a month or so I'd figured out my foreman's schedule and knew when I could sneak a break. During one of those interludes I watched my father work. He never noticed me because his attention never left his looms. I finally found why he wore his nails long. He used them to make knots repairing breaks in the threads of his looms.

That purgatorial summer finally ended, and for the first time I looked forward to going back to school.

Later at home my father asked me if I liked mill work and whether I wanted to continue working part-time during the school year.

"No," I said with as much defiance as I could muster.

"Good," he said. "I don't ever want to see you in that place again." He didn't have to say anything more. He wanted me to see for myself what factory work was all about. It was a life he'd accepted for himself, but not one he envisiond for his son.

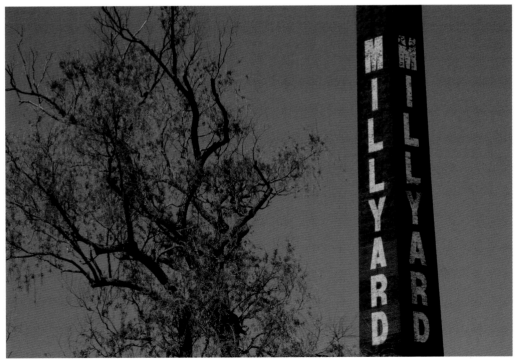

Nashua.

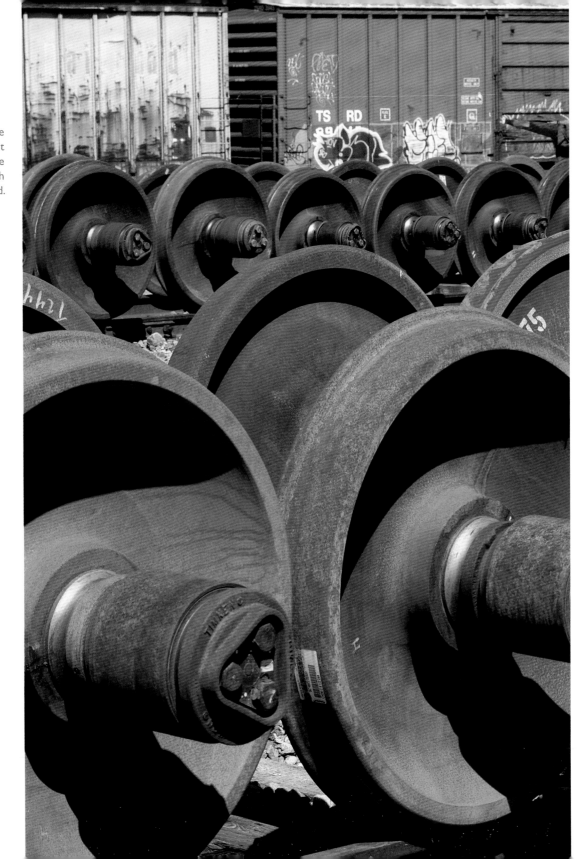

At the New Hampshire Central Railroad freight car and locomotive repair facility in North Stratford.

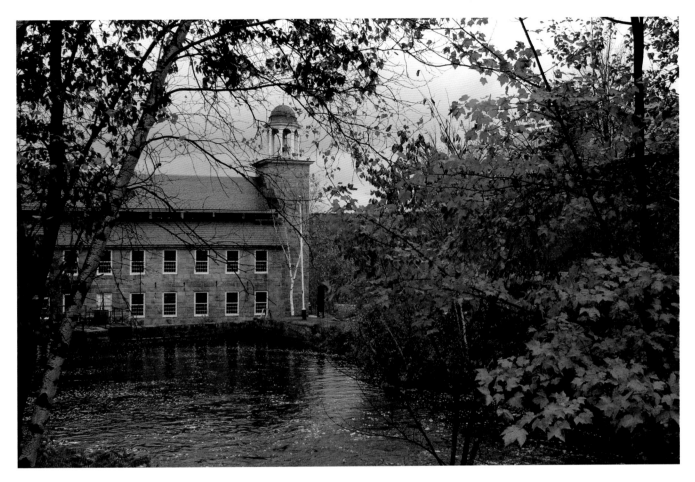

The old mill in Harrisville.

Littleton.

Church and State
combined, in Colebrook.

Leftovers from a yard sale in Manchester.

92

Yard Sale: Harmless or Subversive?

It's a summer Saturday, 6 A.M., and I'm already dressed and hurrying to finish a light breakfast of my own eccentric devising: a salad of lettuce, tomato, and broccoli, cider to drink. I've been yard-saling for a month now. My purpose is to gather tools to split and shape green wood into spoons: hands-on experience for a book I'm writing.

The tools I'm looking for are hard to find in stores and expensive bought new through internet mailing: spoon gouge, two-handed "draw" knife, froe, crooked knife, and shaving horse, which is an old-fashioned foot-operated wooden vice that holds the work while you carve.

I tried country auctions, but I did not like all that waiting for my item to come up, and sharky buyers from down country got on my nerves, and since my hearing is shot to hell and my brain is naturally slow anyway, I had a hard time keeping up with the flow, so I narrowed my search to flea markets and yard sales.

Country auctions, flea markets, used bookstores, antique shops, and thrift stores are manifestations of a phenomenon that started in the last century when Americans suddenly discovered that their attics were full. It all begins with the yard sale.

Mr. and Mrs. America move the stuff from attic onto the lawn for sale. From the yard sale, the stuff finds its way into other people's homes and into flea markets, country auctions, etc. Meanwhile, Mr. and Mrs. America buy other people's stuff from the auctioneer, the flea market entrepreneur, the thrift shop operator, etc. They bring the stuff home, which displaces stuff already in place, which is moved to the attic, which in a couple years goes back down the stairs to the lawn. Round and round we go with Mr. and Mrs. America.

I was introduced to the yard sale by a pro, that is, by someone who buys from yard sales for the purpose of resale. My yard sale guru is a woman about forty-five. She buys blue and white china for her personal collection and jewelry to sell at her booth in a flea market. She set me straight on how to shop at a yard sale.

"The best time to go to a yard sale is early in the morning before the treasures have been taken by other pros or by informed amateurs," she said. "The difference between me and the amateurs is they respect the 'no early bird' warnings, and I don't. The night before, I go through the classifieds with a map beside me. I circle all the addresses, and then I plan my route to hit every promising yard sale before 7 A.M.

"By 9 A.M. you might as well go home, because all the bargain valuables will be gone, but late in the morning you can sometimes pick up really nice big ticket items, like furniture, that the home owner overpriced and is now desperate to get rid off. After lunch, forget it. Good yard-saling is pretty much over by noon.

"Yard sale rules of etiquette are just common sense. Dress is casual. Bring lots of small bills and change; your credit cards will be no good. It may be a faux pas to accost a stranger with conversation in a retail outlet, but at a yard sale it's okay. You're always bumping into old friends, and it's a nice atmosphere to meet new ones. Haggling over price is expected."

The advantages of yard-saling over conventional shopping include bargains and a pleasant atmosphere; the thrill revolves around what my guru calls "the hunt." Some people will furnish an entire second home via yard-saling or an apartment for a son or daughter in college. My yard sale guru once bought a couple hundred dollars worth of tarnished jewelers' silver for five bucks. Me, I've gotten a few bargains, but no bonanzas.

Besides old tools, I shop for books. You never know what you're going to come upon. For example, I found a novel by Winston Churchill, not the prime minister of Great Britain, but the nineteenth-century author from Cornish, New Hampshire.

One of the more subtle pleasures of yard-saling is the op-

portunity to snoop into people's lives. You get snippets of their tastes and desires by the things they'll sell cheap or sell dear. Books are especially revealing. A stack of *Readers Digest* magazines will tell you something about the householders social class and perhaps their politics. Romance, sci-fi, and mystery novels tell you something about their dreams.

The saddest yard sale I ever went to was in a small New Hampshire town back in the 1970s. I'm not sure that the phrase "yard sale" was even in the lexicon on that back road in that little rural slum where a bunch of shacks and trailers stood on a common lot of maybe ten acres, but the spirit was there.

A guy had put an ad in the paper. He was getting rid of his fishing equipment. When I arrived I saw a shack with tarpaper walls. In front was a ten-foot aluminum john boat with oars but no motor, couple of spinning rods, a bait casting rod, two tackle boxes, scores of lures—somebody was lure crazy—and assorted nets, bait tins, bailing pails, and a big wooden box that said Night Crawler Ranch. In contrast to the environs of shacks, yards without flowers or lawns, junked cars, and discarded appliances, the boat and fishing equipment were laid out nice and neat.

A sign in red crayon on cardboard said, "$200."

I was intimidated by the scene. Somehow I expected a big dog to come leaping out at me. Instead, a gaunt, unshaven man of about sixty with sunken cheeks and a sallow complexion opened the door of the shack.

"What are you asking for the boat?" I asked.

He shook his head no. "I can't sell the boat alone. I want to sell everything in a piece to one buyer."

"I'm a fly fisherman. I don't have any use for spinning rods and bait. I just want the boat."

The man paused. "I kinda hoped the rig would all stay together."

"I can relate, but two hundred is way over my budget," I said. "How come you're selling?" It was impolite to ask, espe-

cially since I could have guessed the answer, but my reporter's bluntness and instinct for verification got the better of me.

The man pointed to his throat. "The big C."

I bought the boat for $75 and it served me well for five years before I replaced it with a canoe that rewarded me with tennis elbow.

The yard sale, flea market, country auction, used bookstore, thrift shop, and antique store are part of a rebellion against retail, an underground economy. They undermine globalization, and they cut into the profits of corporate America. For every set of darling baby blue pillow cases snatched up for a buck fifty at a yard sale, a set of baby blue pillow cases manufactured overseas and sold at WalMart goes wanting for a customer.

Heck, the antique shops have even undermined traditional spelling by fiddling with the word shop, which is sometimes spelled with an extra "p" and "e," and replacing the perfectly functional definite article "the" with the archaic "ye," as in Ye Oldde Antique Shoppe of Verbal Horrors.

The rebellion of the underground economy starts with the yard sale. Kids run around on the lawn, little old ladies and little old men pick through merchandise, and suddenly money changes hands. Is there an accountant in the house to input the sales into a database so Uncle Sam can get his fair share? I don't think so. I think that the yard sale thumbs its nose at the Internal Revenue Service. Maybe that's why we like it so much.

On this particular summer Saturday morning I shop at an unadvertised yard sale. Some people, especially in crowded neighborhoods, don't bother with an ad in the paper. They just tack a couple of paper signs to trees and telephone poles first thing Saturday morning, another subversive act, probably illegal.

Stumbling upon an unadvertised yard sale is always a thrill, because there's a good chance to beat the dealers to the valuables. It turns out that this particular yard has no tools for sale, but I do find a stack of post cards from the 1940s. One shows The Old Man in the Mountain in all his former glory. The

message, written in faded fountain pen ink, says, "Be home soon—love you, Alice."

College graduations, pipe dreams, illnesses, weddings, deaths in the family, sports triumphs, even broken hearts: with a little imagination and a detective's eye you can read the age old stories of humanity in the stuff sold in a yard sale.

It took me about a year of no-rush searching before I rounded up the old tools I needed to make wooden spoons. I got them all from flea markets and yard sales, except for the shaving horse, which I built from a plan in a book, which I bought at Left Bank used book shop in Hanover.

Beside the road in North Haverhill.

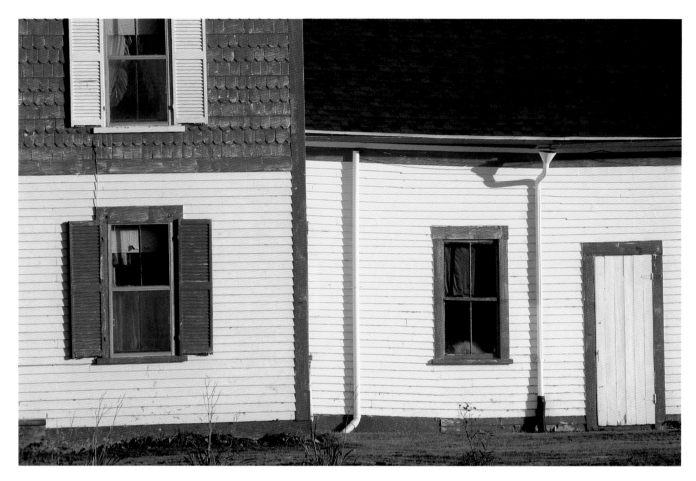

Sunset in North Haverhill.

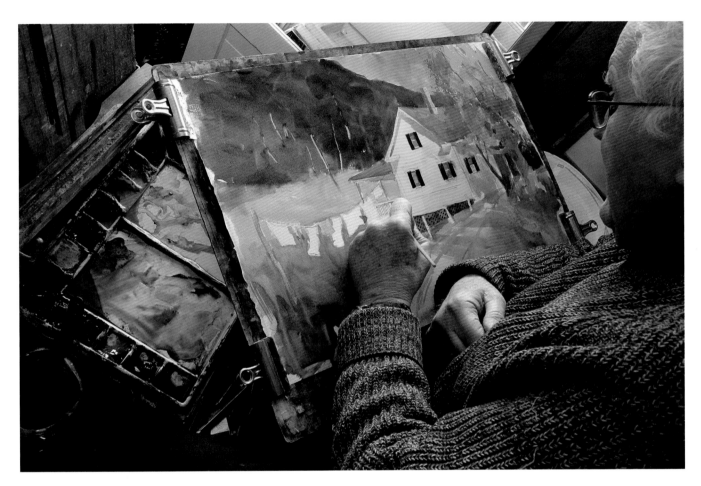

Larry Howard painting in Canaan.

Snowboarding at Whaleback
Ski area in Enfield.

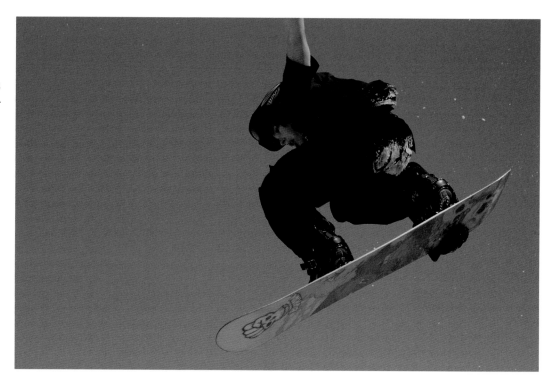

X-treme skiing in Enfield.

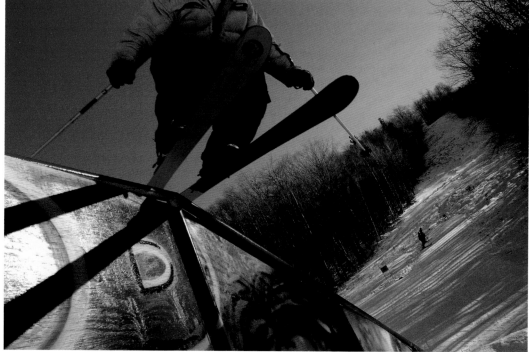

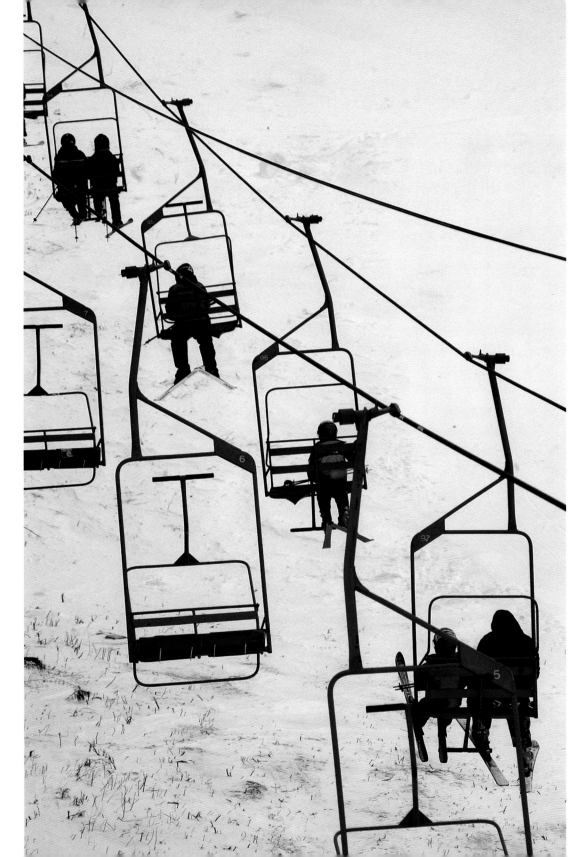

Ski lift at Whaleback
Mountain in Enfield.

99

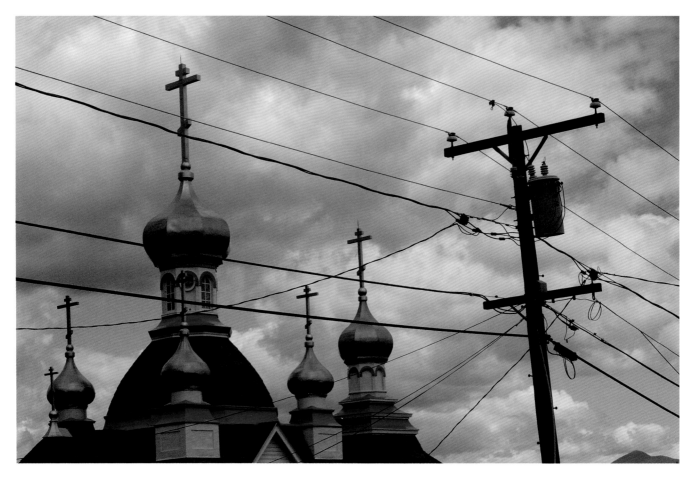

On top of Russian Hill in Berlin.

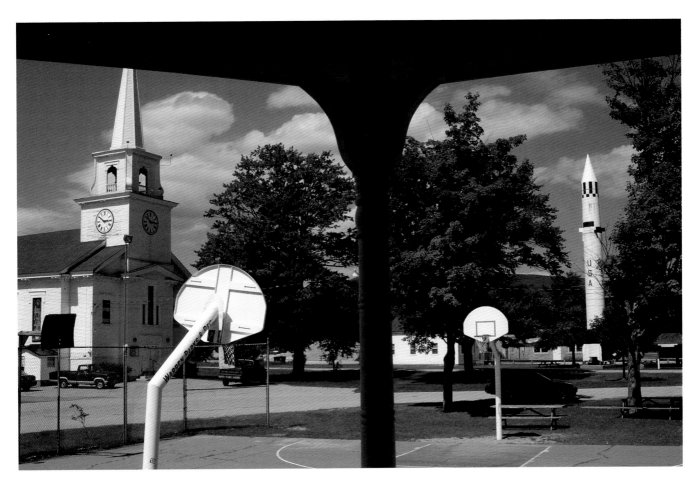

Looking through the bandstand in Warren.

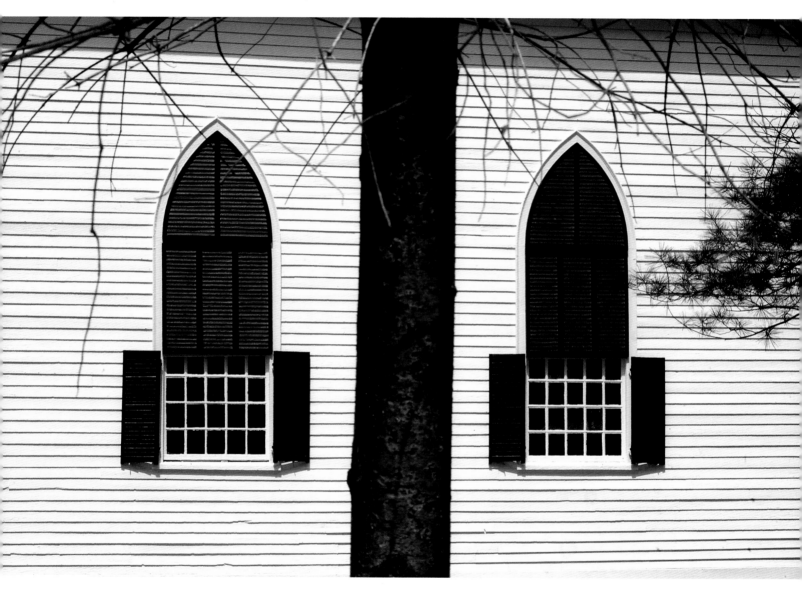

Canaan.

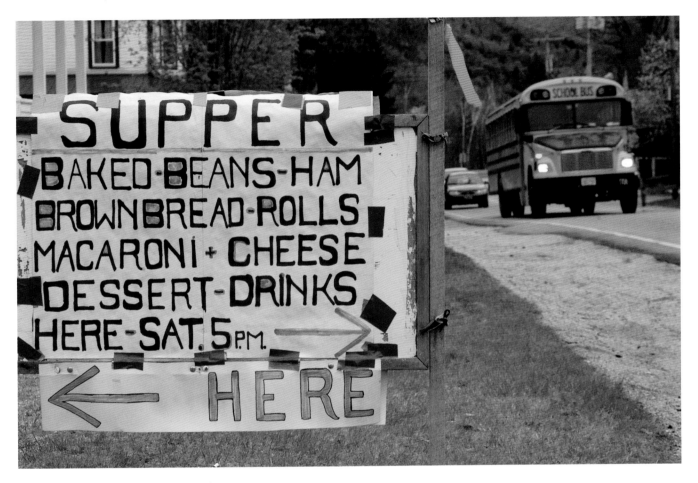

SUPPER
BAKED·BEANS·HAM
BROWN BREAD·ROLLS
MACARONI + CHEESE
DESSERT·DRINKS
HERE·SAT. 5 P.M.
← HERE

Which way the church supper in Warren?

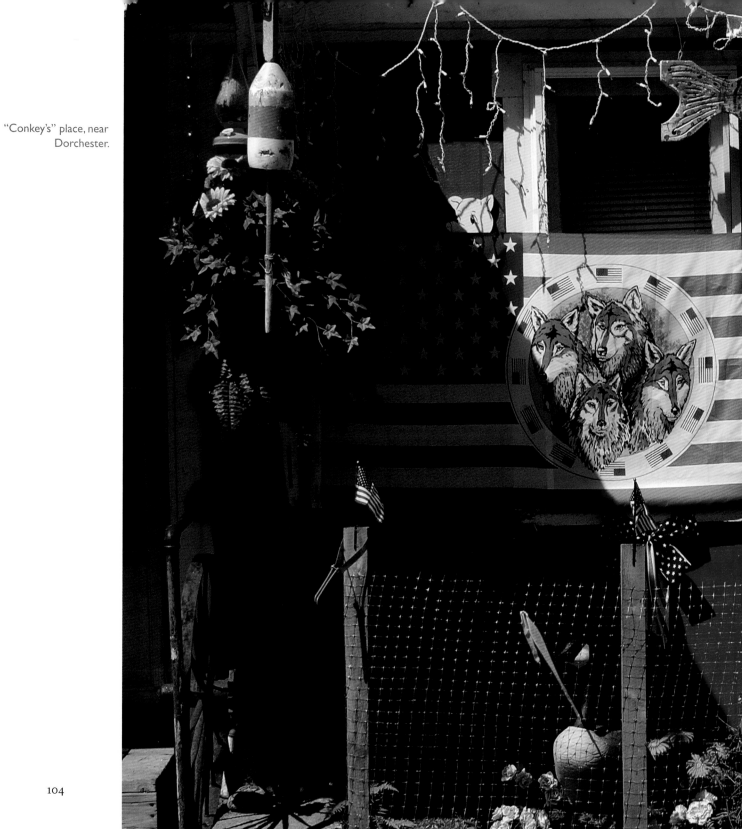

"Conkey's" place, near Dorchester.

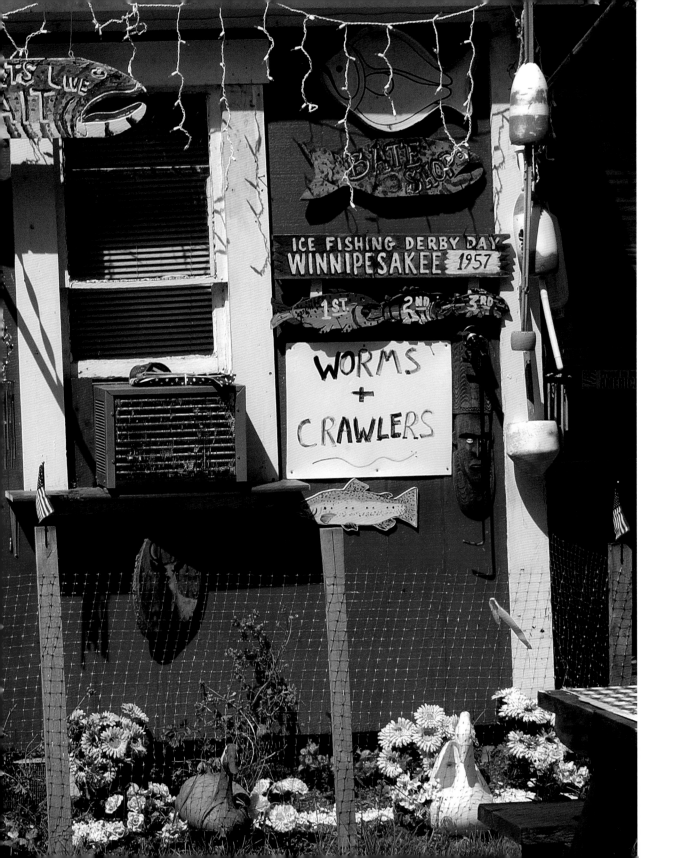

105

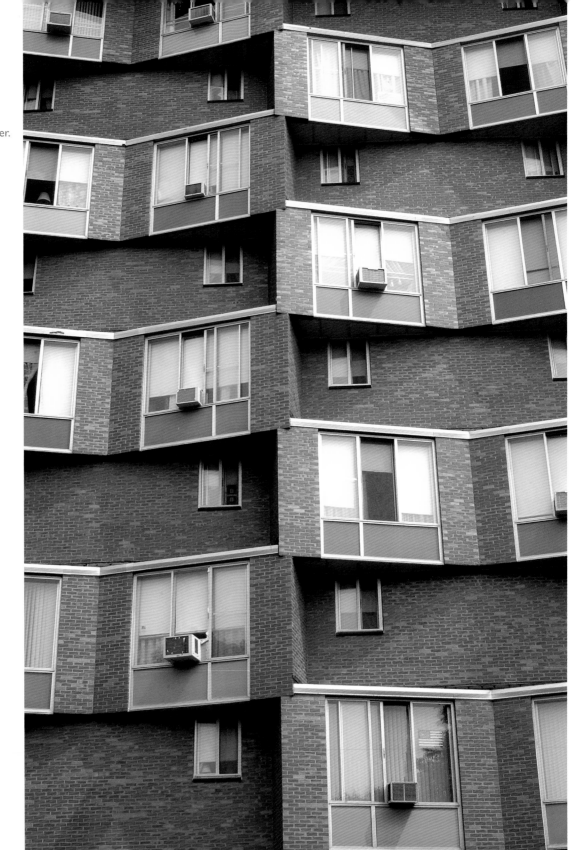

Manchester.

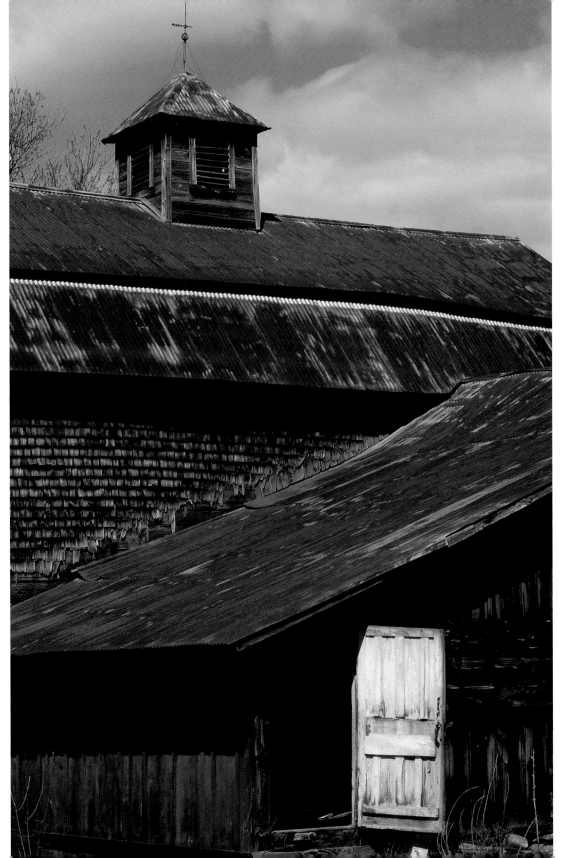

Piermont.

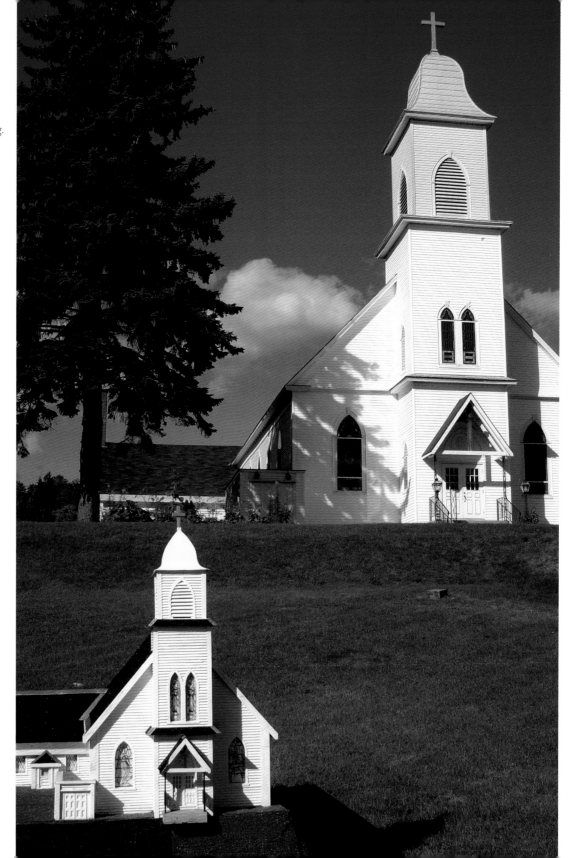

Offspring.

108

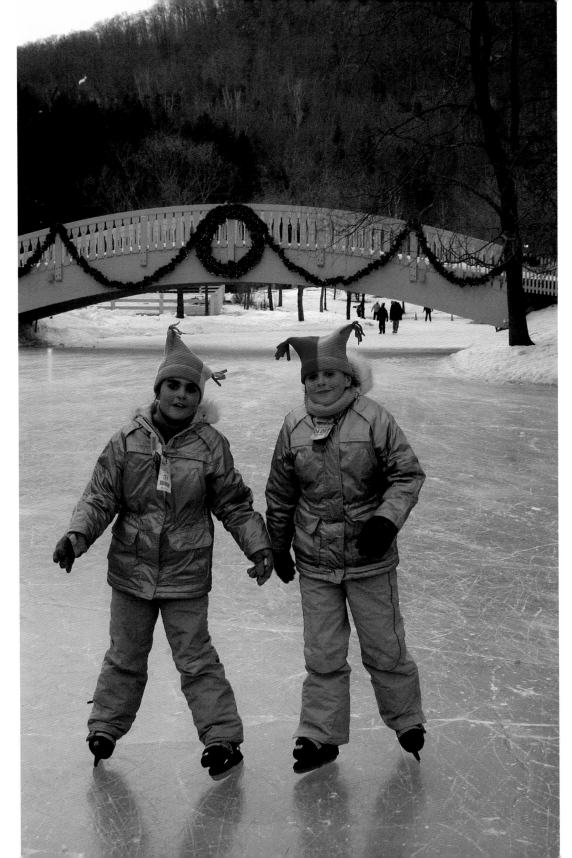

Skaters, in Jackson.

A lobster on the wharf in Portsmouth.

Center Harbor.

Legendary *Yankee* magazine and *The Old Farmer's Almanac* editor, Judson Hale, in his office, in Dublin.

112

NO DOG FOULING

Pursuant to city ordinance persons owning possessing or controlling dogs who fail to carry an article or mea~ to remove its ~ dispose of consist~ be subject to viol~

CITY ORDINANCE C~

Manchester.

Rugby at Kimball Union Academy, in Meriden.

114

Bath.

Facing page: Fall on the Kancamagus Highway.

NATURE
PATTERNS

Jackson.

Touching It

The winter of 1968–1969 was the coldest and snowiest in years. I didn't mind. I was in love. Winter was still hanging on late in March when my bride and I moved to Nelson where we rented a barn renovated into a sort of apartment.

Our barn home had dark board walls, a tiny kitchen and a tiny bathroom, but no bedroom; living and sleeping spaces flowed together from the hearth of a fieldstone fireplace. It was a rustic paradise and we embraced it.

The focal point of our lives in the barn was the fireplace, which threw off enough heat to warm us during the chilly transitional season between hard winter and true spring. Mounted over the fireplace was the head of a buck deer, who from the expression his face struck me as not too bright. I put a cigarette in his mouth. He looked like Humphrey Bogart with antlers.

I quit smoking more than thirty years ago, but I still miss my Camels. Thinking back, I see myself sitting by the fire with a beer in one hand, a cigarette in the other, and a hand around my beautiful wife's shoulder. I suppose I had three arms in those days. With its continually changing visual display, its squeaks, hisses, snaps, crackles, and pops, the fire gave you everything a TV did, but without the commercials. At night from the bed while my wife slept I'd watch the glow of the fire through slit eyes and wonder about the future, how I would make a living, what I would do to justify my existence.

The cold weather lingered. The fire in the hearth would heat up the stones, which would throw warmth like a radiator. It was nice heat, but by the middle of April we were on the verge of running out of wood. The air was still cold, and plenty of snow lingered on the ground. I was seriously short of money, so I wasn't about to buy any firewood.

I approached the landlord with my dilemma. He and his wife lived next to the barn in a nice, unostentatiously remodeled farmhouse. It was the last property on a dead end road with no other dwelling in sight.

The landlord was a retired engineer with roots in Holland, who managed to combine alcoholism with physical fitness. When he was drunk he'd frequently announce, "I'm a Dutchman, I'm a Dutchman." During the day, he alternated his chores with vigorous exercise. I'd often see him jogging on paths in the woods: seventy years old, fair-haired, fit, strong and handsome, if a bit red in the face. He'd start drinking late in the afternoon. He was never a mean drunk, but by progression good-humored, garrulous, oratorical, and finally incoherent. His wife was petite and shy, a comforting person, who never complained though she did not seem happy. I remember her with affection because she was kind to my young bride.

Unfortunately, the landlord, too, had run out of firewood. He was warming his house with the oil-fired furnace. There was no furnace in the barn, only the fireplace. He had a suggestion.

"Follow me," he said, and he walked me out into his forest and showed me a small stand of dead hardwoods. I could have them for the cutting, he said, and then we went back to the house and he invited me in for a drink. A couple hours later, he was telling me: "I'm a Dutchman, I'm a Dutchman." That was when I left.

The next day I rented a chain saw. I'd never been good with tools that demanded precision. The chain saw was crude and direct, like a curse word. It was the tool for me. A plus was the excitement in the latent danger of the instrument. I'd been scared of a lot things in my life—heights and humiliation, to name two—but the chain saw was not among them. In two days, I cut, moved, and stacked enough wood to last us the rest of the heating season. The work tired my body and calmed my spirit.

I've been cutting firewood off and on ever since that cold spring in 1969 and burning it to keep warm. Adaptation of old New Hampshire saying: Wood warms you when you cut it,

warms you when you move it, warms you when you split it, warms you when you burn it, and warms you yet again when you contemplate it.

My rule is to cut down trees that are probably going to be choked out by other, bigger trees. This kind of "selective cutting," as they say on the environmental circuit, preserves the apparent character and appearance of the forest, though it does subtly alter Nature's intelligent design, which gives this wood cutter the illusion that he is some kind of subversive.

New Hampshire is in a transitional zone between the southern hardwood forest and the Canadian boreal forest. The result is a tremendous variety of trees all mixed up together. But when I go in the woods, I see more than oaks, birches, beeches, maples, pines, and spruces. I see my friends from St. Joseph's Elementary School, the sons and daughters of Ireland, Italy, Poland, and French Canada. I see the people I covered at town meetings as a news reporter: Yankee farmers and town selectmen, educated newcomers, and back to the landers. Of late I see students I've taught at Dartmouth College over eighteen years: from every state in the union, with family origins from Europe, Africa, Asia, Latin America, and Native America. For me the northern forest is a metaphor of the various races and ethnic peoples that make up my world, and the surprises you find when you get to know them.

Who would guess that box elder often reveals blood-red streaks when you split it? Or that black birch, an ordinary looking tree that is upstaged by its flashier white birch cousin (New Hampshire's state tree), holds an exotic smell within its tight, black bark?

The two most dangerous professions in America are commercial fishing in cold waters and logging, both of which are practiced here in the great Northeast. Amateur wood choppers such as myself are not exempt from the dangers. A few years ago one of my colleagues at Dartmouth was killed by a tree he was felling. So far I've escaped serious injury, though I've had a few close calls.

Cutting, chopping, and moving wood inevitably leads to scrapes on your arms and legs, slivers in your hands, and smashed fingers. One day I crushed an index finger and the inflammation under the nail resembled an abstract painting by Mark Rothko. A very rewarding injury. I especially enjoy a good sliver, digging at it with the tip of my jack knife until I can reach it with my teeth. When I pull it out, that kinky pain followed by relief is precious.

When I cut firewood on my wood lot, I survey an area and ask myself what I can take out that will make the forest look better. I call this activity subtractive gardening. I put myself in competition with God for aesthetics. I cut the stumps low and place rocks on them for decoration. In the end, if the area looks worse I ask for forgiveness. If it looks better I feel as if God dwells within me. Either way the activity is rewarding to my soul, if I have one; either way I bring sticks home to burn in the hearth.

Most of the firewood I gather is not from my wood lot; it's scrounged from all over the place: the landfill, roadsides, construction sites, sand bars from the Connecticut River where driftwood collects, and neighbor's yards after a wind storm. Wood scrounging for fuel rewards brain neurons in some atavistic way.

The most pleasurable part of gathering firewood for this amateur is splitting the wood by hand with ax, wedges, and sledge hammer. Every time you split a piece of wood you're in for a visual and olfactory delight. For the person paying attention there's more surprise and mystery in a stick of wood than in a stick of dynamite.

I don't know if beauty in Nature is in the eye of the beholder or whether God put it there for us to discover, but I know that I see a new and exciting object every time I split a log for the wood stove. It's as if I'm in an art gallery featuring work by a master sculptor in which I am allowed to touch the pieces.

Sight and smell are nice, but the best reward for the amateur wood gatherer is tactile. You touch the bark of a tree when you cut it, you touch the log when you pick it up and toss it in the bed of the pickup truck, you touch the log when

you unload the truck, you touch it when you bring it to the chopping block, you touch it when you split it, you touch it when you stack it, you touch it when you bring it to the stove or fireplace. When the fire burns and you look at the flames, you remember the history of the log not only with your mind but with your hands.

My wife and I lived in the barn through the summer, then moved on. Recently, I returned to Nelson. Its identity as a small town full of rueful people has remained relatively un-damaged by the megalopolis crunch, because no state or federal highway runs through it. The farmhouse and barn where my wife and I spent the first months of our marriage were still there, though under different ownership. Later, I happened to stumble upon the graves of the landlord and his wife in a cemetery in Harrisville. I put my ear to the ground, and heard the landlord calling out his identity, "I'm a Dutchman, I'm a Dutchman." His wife remained silent.

Etna.

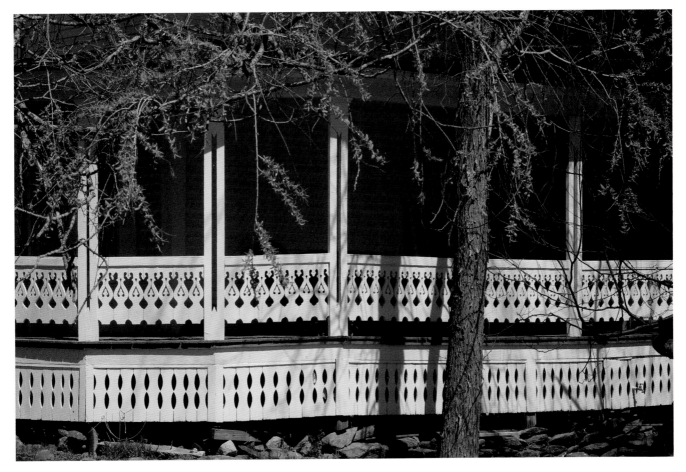

Swiftwater.

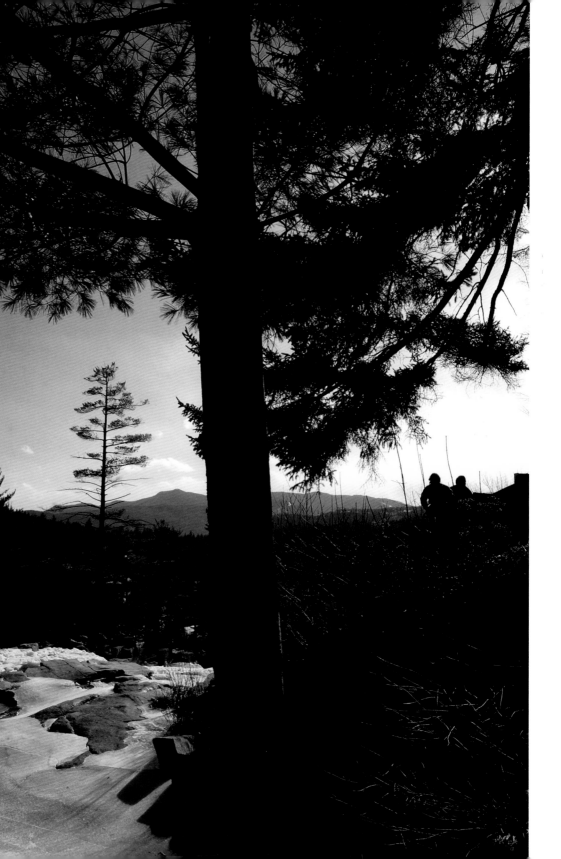

Jackson.

Grafton.

125

Along the Kancamagus Highway.

Later along the Kancamagus Highway.

The Third
Connecticut Lake.

128

Lakes and Ponds

Back when I was a reporter for the *Keene Sentinel* I had an argument with the City Planner. He was a fine administrator, but like most city planners he was from out of state and had only a superficial understanding of local culture and mores. (It has always amazed me that communities shop out of state for school superintendents, police chiefs, and town administrators. Meanwhile, local talent, to be fulfilled, must leave its roots. Success cannot to be sought in the home town: that's a continuing American tragedy.)

I was interviewing the City Planner about a plan that included a man-made water body perhaps a couple acres in size. The City Planner referred to it as a lake. I took offense. "It's not a lake, it's a pond," I said.

We went round and round over this lexical matter without resolution, parting at least for that moment as bitter adversaries. I was more angry with myself than with him for my failure to articulate the subtle, local differences between a lake and a pond. According to my Merriam-Webster Dictionary a lake "is a considerable inland body of standing water." A pond "is a body of water usually smaller than a lake." The definitions suggest that the words lake and pond are used loosely. Not very helpful in resolving an argument.

If one's standards for "considerable" are the Great Lakes then our Lake Winnipesaukee, the largest inland water body in the state, would have to be a pond. Someone from the desert might regard any water body larger than a mud puddle as considerable, and therefore the City Planner's two-acre water body would be a lake.

An old New Hampshire joke about how Canobie Lake acquired its name, told to me by my friend Jack Brouse of Salem, makes the point. Centuries ago an Indian from the New Hampshire Lakes Region wandered south until he came to the little standing water body between what is now Salem and Windham. The Indian said, "Can no be lake."

Local usage based on topographical features has created more refined definitions. In New Hampshire, lakes are deep, ponds are shallow. Lake water is spring fed (or anyway, said to be spring fed). Pond water is brook fed. (By the way, the "creek" has inched its way into New Hampshire speech. A shame. In traditional New Hampshire lingo, there are no creeks. There are rivers, brooks, and streams.) Lake water is more or less clear, pond water ranges from murky to rust-colored. Lakes are usually larger than ponds, but not always. A large, shallow, murky water body would be a pond.

Town records reveal that the word "pond" was often used in its Middle English sense to mean water impounded behind a dam. (Note that the word "impound" impounds the word "pond". Pond was p-o-u-n-d in Middle English.) I remember an old document that referred to the water contained in Dublin Lake as Dublin pond, lower case "p". Since nearly all New Hampshire lakes are dammed to control water levels, they can also be called ponds. And of course if one relaxes the word "considerable" one can say that all ponds are also lakes.

I developed an ambivalence toward lakes and ponds that started with Robin Hood Park Pond in Keene, a retired reservoir that people in my neighborhood called The Rez.

I figure I threw an average of fifty stones a day in The Rez for ten years. That comes out to more than 180 thousand stones. I was trying to throw a stone to the other side of the water. Some time after I turned fifteen, I succeeded. A few weeks later, clowning around, I broke and dislocated my wrist. I never again was able to throw a stone across The Rez. Last time I tried it my stone reached a quarter of the way across and my elbow hurt for weeks.

When I was a little kid I looked forward to the day when I would be old enough to go swimming at the city swimming area at The Rez. There was a roped off zone and a diving board. The place was crazy with wild, splashing kids. The year

I was eligible, around eight, I think, swimming at The Rez was banned.

I asked my mother, who was a nurse, why. She told me that you could get polio by swimming at The Rez. I'd seen a few kids with polio, one of whom died. Suddenly, The Rez was a foreboding place.

In winter the city plowed snow off the ice for ice skating, but I always jumped the gun and one year almost fell through on thin ice. I vividly remember the sound of the ice cracking. I imagined that the water was alive and wanted to suck me down into its depths.

Another water body that brought me some angst was Granite Lake, which straddled the Nelson-Stoddard town line. It was about a mile long, half a mile wide, 111 feet deep in the middle. Summer cottages were close together with runabouts moored to docks, sailboats at anchor, and canoes pulled up on shore.

I could fish, swim, water ski; I could hang out and play board games or cards with other kids in the alcove under my parents' second-story porch; I could pick blueberries under the power lines on the hillside; I could boat over to the General Store, which was operated by Joe Dobson, a former pitcher with the Boston Red Sox. The lake was an ideal place for me to while away the time when my parents took their two-week vacation, but I hated it.

I hated it because I could find no other kids my age in the vicinity to play with and because it took me away from my favorite summer pastime, baseball. I sulked.

Matters grew worse in my early teen years when my uncle, who owned the cottage on the waterfront, died and my family inherited it and started spending entire summers at Granite Lake, an easy commute to my mother and father's work places. I grew morose, which led to introspection, which led to reading habits, which probably led to a career as a writer, but at the time I had no glimpses into my future. I was looking for somebody to blame for my unhappiness. I could have blamed myself or better yet my parents, but I blamed the lake.

Then something happened as if to validate my growing animus. A youth I had a nodding acquaintance with drowned in Granite Lake. I heard of the accident through the rumor mill; maybe it was because I never learned the true story or the details of the accident, or maybe it was because nobody I knew seemed to care, but this young's man's death began to haunt me. It haunts me to this day.

One hot August night I was sleeping on the porch of my parents' cottage. I awoke around 2 A.M. in a nightmare. I was in some kind of strange environment where the laws of gravity did not apply. I drifted aimlessly in a viscous medium. And then I saw a figure coming toward me, eyes open, mouth agape. It was the drowned youth. I suddenly understood that it was I who had drowned and died. That was when I woke up.

The lake was 1,200 feet above sea level and some summers it never quite warmed up, but this particular summer had been unusually hot and the water was tepid. It always felt warmer at night. I decided to go for a swim to try to work off the tension of the nightmare.

I put on my swim trunks and sneaked out. Normally, I'd run into the water until it was thigh deep, then dive in to make as much ruckus as possible. But on this night I wanted quiet, so I waded slowly out until my feet no longer touched bottom. I swam side strokes so as not to make a splash.

The water was silky; it was like being touched. I swam without thinking, unaware of time. I stopped, floating as still as possible; I waited for the ripples to flatten; I waited for something close to absolute quiet. I thought there might be wisdom in that quiet, or peace, something better than myself. I was maybe a hundred yards from shore.

Ahead I could see the lights of cottages across the lake; in front of them was Granite Lake Island silhouetted against the moonless, starlit sky. On weekends my father would take his motorboat out to the island along with trash cans. He'd spend a couple hours picking up litter. It was his way of showing his love for Granite Lake, a love I did not share.

I started swimming toward the island. It was probably a

little less than half a mile away, but I had never swum that far and it was night and I was alone. I felt very daring and just a little bit frightened.

I was halfway out to the island when I heard the roar of a Chris Craft speed boat. I recognized the boat from the sound. It was owned by a local surgeon, notorious for his skill, arrogance, and hard drinking. I never actually liked his boat, but I admired it, especially the finish on the hull, teak or mahogany, and the rich, throaty sound, the nautical equivalent of a Harley Hog. I loved that sound. Though not on that night. Not in the water, in the dark. The boat tore up and down the lake at great speed, at one point not thirty feet from me.

It headed for the other side of the lake, its sound fading. Before I could relax, the boat turned and appeared to be ploughing right for me. He's going to run me down, I thought. I could almost feel the propeller chewing into my flesh, see the boat riding over me, hear the falsetto whine of a boat propeller coming out of the water after the craft runs up on an object.

The surgeon, or whoever was operating the Chris Craft at 2 A.M., would not be able to see me until the last moment and it would be too late. No point in screaming. I could not be heard above the roar. Something else prevented me from calling out: fear of humiliation. It was a pretty stupid move to swim out in the middle of a lake in the middle of the night, and I didn't want anybody else to know. Better they find my body than they hear me hollering hysterically for help.

I swam on for what seemed like hours. I believed that only the sanctuary of the island could save me. Soon I was in its shadow that blocked the stars and I knew I was safe, and then it struck me that I could not hear the Chris Craft, had not heard it for a while now. Apparently, the joy ride was over and the boat had docked. The night was quiet again but I had not noticed.

I climbed up on the rocky shore to the ledge where in the daytime we kids loved to dive. The water was still a little riled from my frantic swimming. I sat on the ledge, arms wrapped around my knees.

The island, far away from my parents' place on the east shore, was very close to the north and west shores. A few lights were on at the Notre Dame Camp for girls. A couple years earlier I and an older boy, a policeman's son, went out to the island by boat in a sunny afternoon. My friend had some police binoculars and we watched the girls swimming within their roped-off area. Somehow it was a lot more exciting to look at girls through binoculars as they splashed around in the water than it was when they were in front of you.

I probably spent an hour on the ledge, just looking at the stars, and then I swam back to my parents' place without incident, but my confidence was shaken. It seemed to me that the world was a dangerous place, its perils unpredictable, my own abilities meagre, my nerve wanting.

Many years later, after my mother died, I had a chance to buy the cottage from my father at a low cost and have it for myself and my family. But in my mind's eye I could see my own confused youth and miseries, I could see the ghost of the young man who had drowned, I could see the surgeon's Chris Craft roaring up and down the lake for a thousand nights, I could see my daughters drowning in those beautiful waters. My brothers and I sold the place for my father, and I had no regrets.

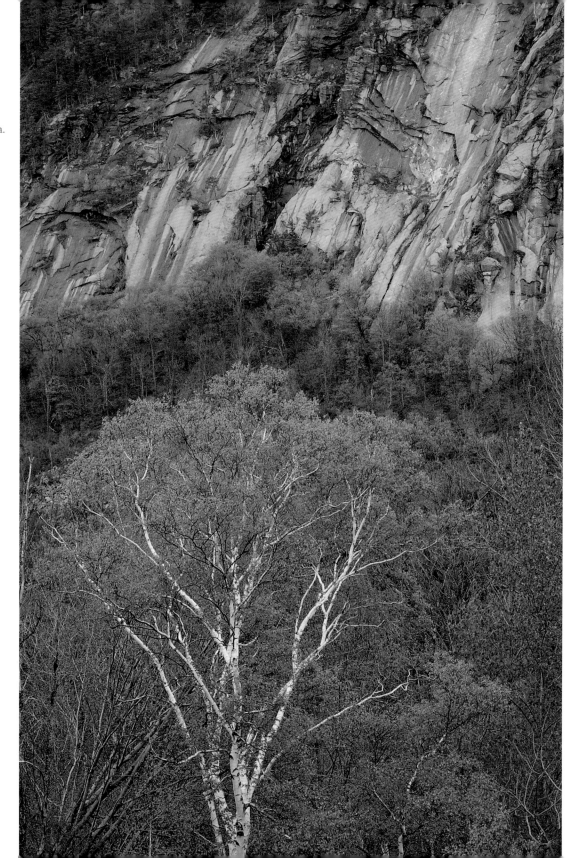

Spring near Franconia.

High Autumn.

Pumpkins in Piermont.

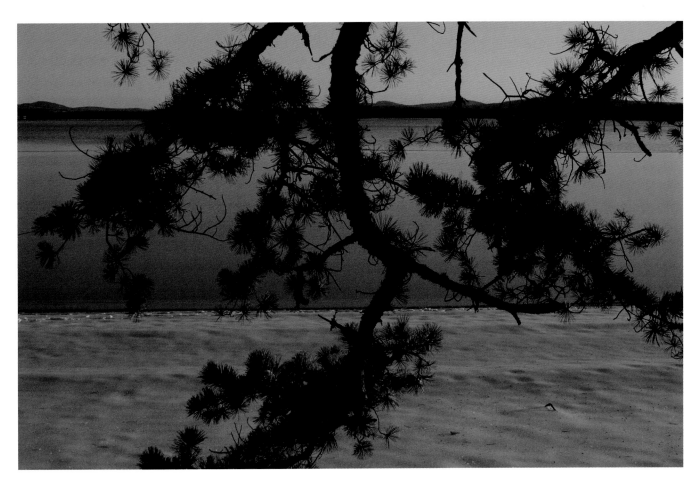

First freeze on Lake Ossipee.

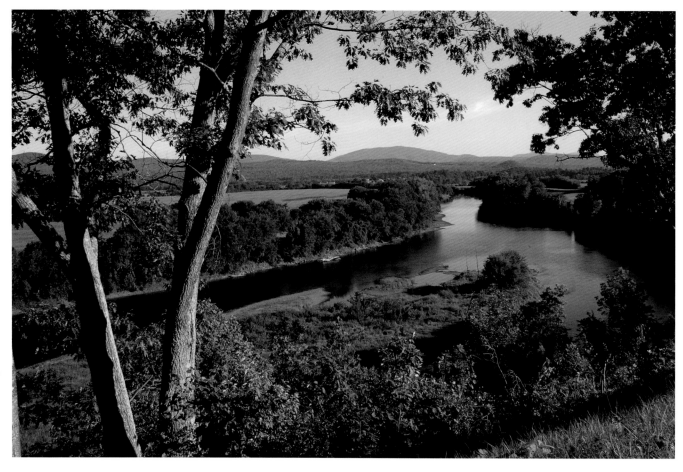

Along the Connecticut River, looking to New Hampshire from the
Vermont side.

Sunset near Plymouth.

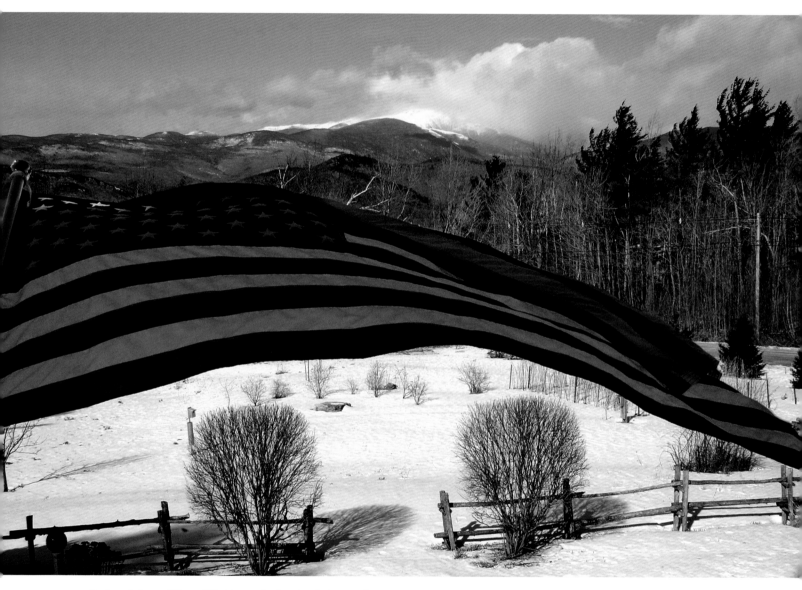

Backyard view of Mount Washington in the clouds (as usual).